STROUD

STROUD

RUPERT RUSSELL

The History Press

This book is dedicated to the hope that
Stroud brings to me.

First published 2019

The History Press
97 St George's Place, Cheltenham,
Gloucestershire, GL 50 3QB
www.thehistorypress.co.uk

British Library Cataloguing in Publication Data.
A catalogue record for this book is available from the British Library.

ISBN 978 0 7509 8990 9

Typesetting and origination by The History Press
Printed in China.

INTRODUCTION

Photographing Stroud was good for my soul. It's colourful and musical, the air is often filled with wafts of street food, and artisans line the roads and squares selling their passion-born produce. I met warm, welcoming people happy to engage with me and my camera: hippies, Tories, revolutionaries and citizens of the world. Dewy-eyed teenage dragon slayers, morris dancers, wizards and bad guitar players. Stroud wants to repair the broken, make use of the old and be a friend to the new; a complex clockwork of cultures. It seems to work, though, and I love it!

Those of you who are familiar with Stroud will probably notice that I spent a lot of my time wandering around the farmers' market, and the simple fact is that it's a street photographers paradise! I could have filled a book twice the size of this one just by standing on the corner of Threadneedle and Union streets for a few hours on a Saturday morning!

If you get the chance to visit Stroud, you'll find a throbbing, layered, cultural fusion of activity. It's not immediately obvious – you must explore to uncover its treasures; it has its own power source! There's hope here, too: people trying to save humanity from itself and some wanting it to stay just the same. If Stroud was a spacefaring colony set adrift from earth, cast into the wider universe on a quest to find a second home, I'd sell up and book tickets. And I think we'd do all right.

I was born in London in the late 60s, but now I live down the road from Stroud in Uley, with my brilliant family. I've been an actor, a chef and a roller-skater. Photography has been part of my life for most of my years. It didn't get serious until the digital age, when I gained control of the taking-pictures process in 2007 with my first 'proper' camera. Portraiture was my thing, and my friends and family were the plots and stops of my learning curve. I don't know why the power of a frozen scene appeals to us humans; stopping time, reflection, the perfection of a moment caught forever.

The philosophy of my photography is loose, but is tethered to an ideology by a frayed length of parcel string: I want to change the world but hold no expectation that my photography will play any part in that process. Change happens, needs to happen, whether we like it or not, be it gentle or forceful. I am convinced that humanity is a beautiful thing and have no desire to remind or record the ugly side of us. I hope my children live to see the turning of the tide.

For this book, I gave myself a couple of basic rules inspired by a street photographer I greatly admire, and whose philosophy has helped shape my general approach to street photography – no exploitation, no humiliation. Thank you, Jamie Windsor. This is how Stroud appears to me in all its groovy glory.

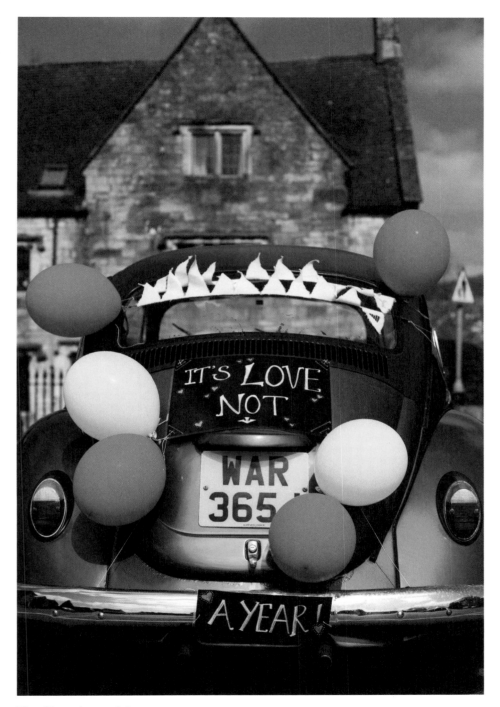

The Stroud people's wagon

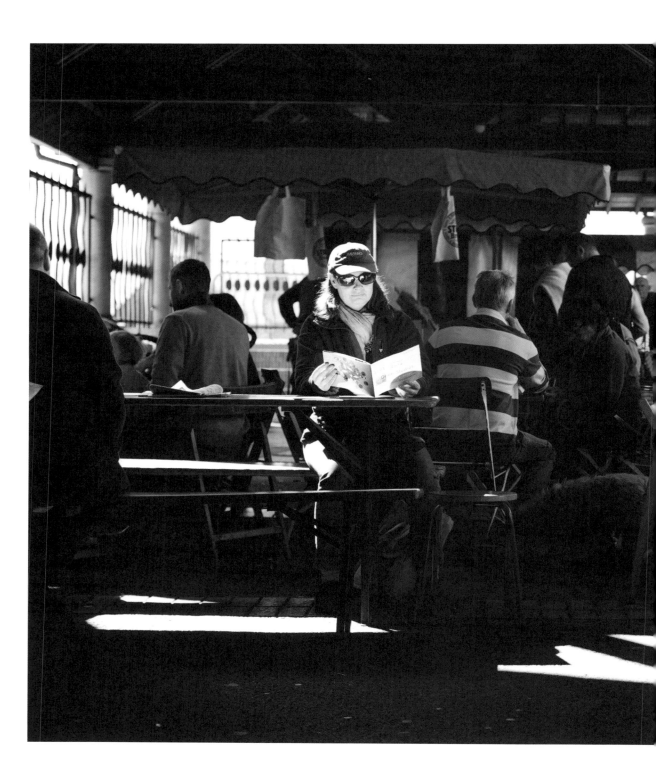

The tourist sitting in the
light of the morning sun.

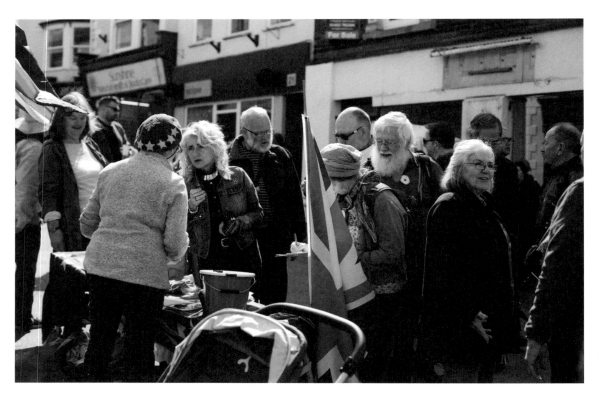

In or out? The campaign rages on!

Opposite page: Jake & Elwood.

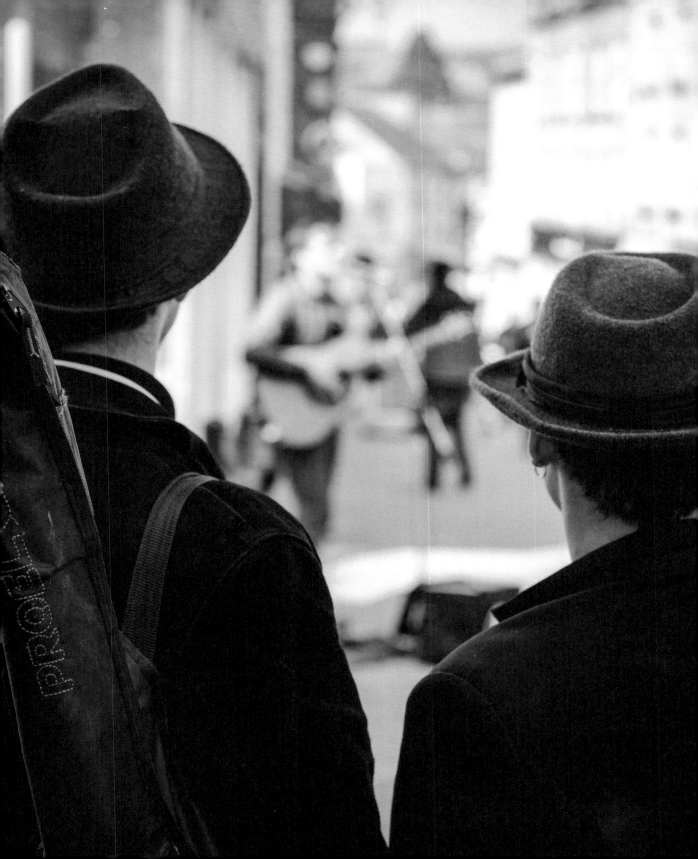

A Frankenstein bike: parts salvaged and bolted on, and its life 'unnaturally' preserved.

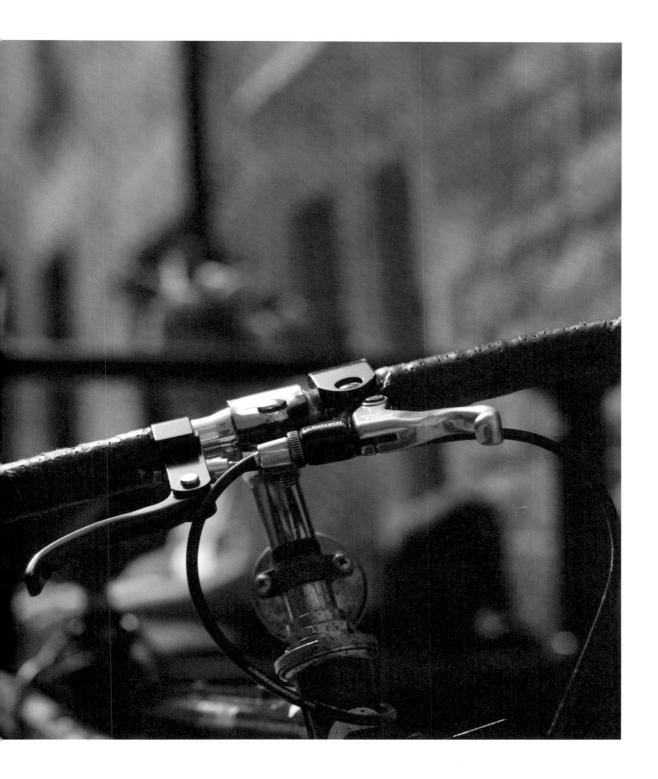

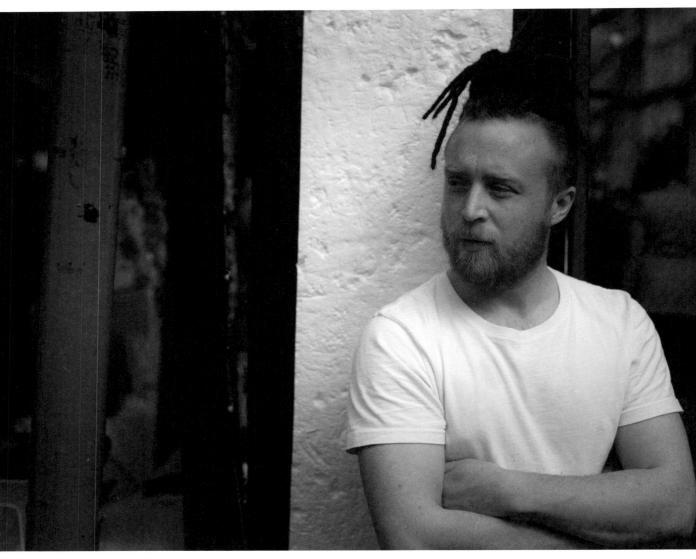

I'm sure Stroud has the highest concentration of Caucasians with dreadlocks in the known universe!

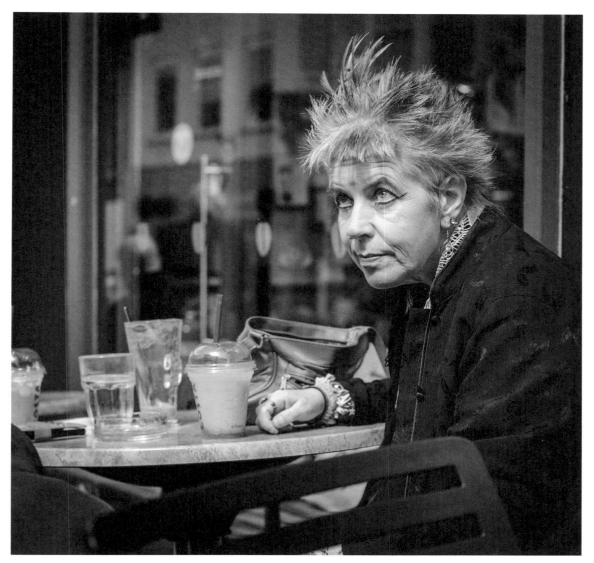

We are one hundred people every day.

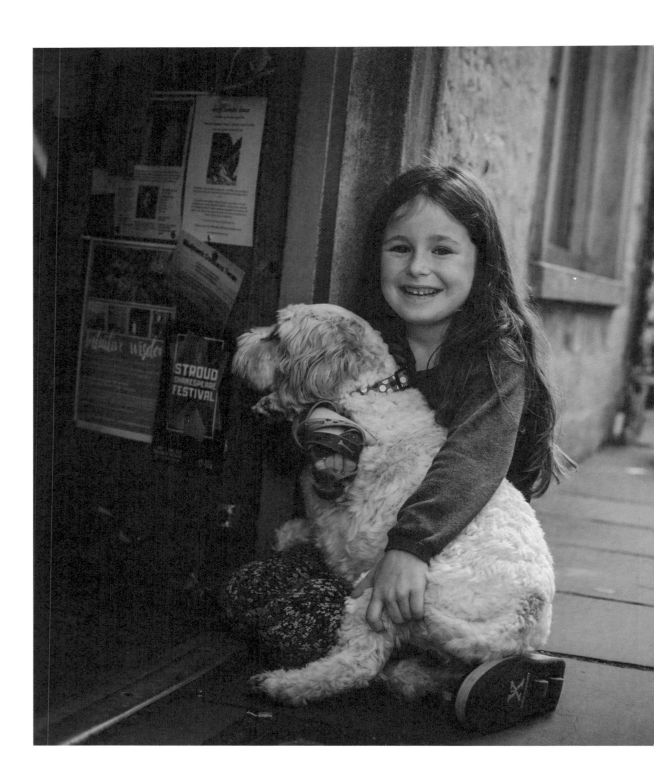

Mum was inside chatting with the shop owner and she didn't want to leave the dog outside alone.

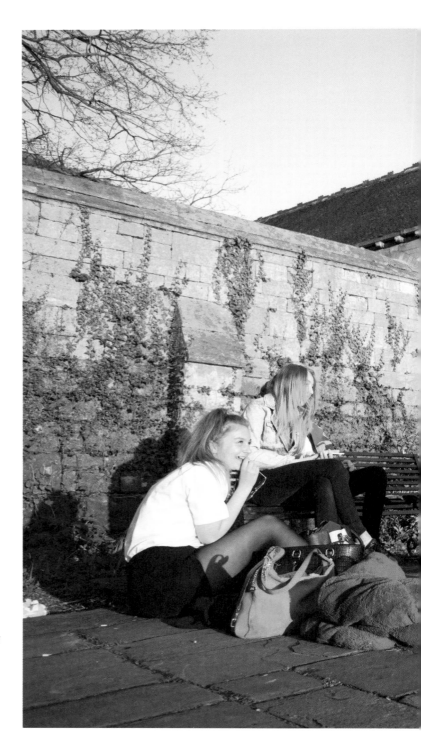

I had a brilliant exchange with this lot. After asking if I could photograph them we had some colourful banter before they threw down some 'street' poses for me.

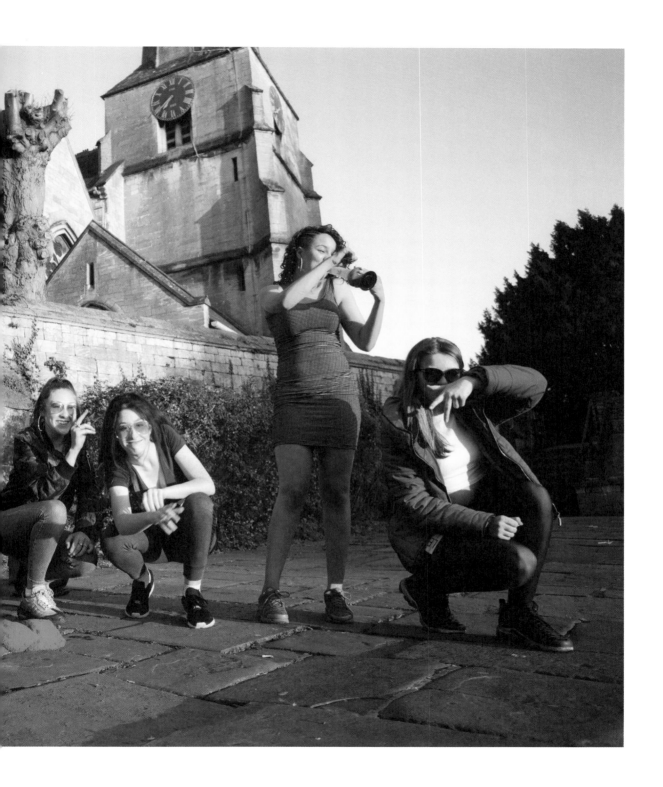

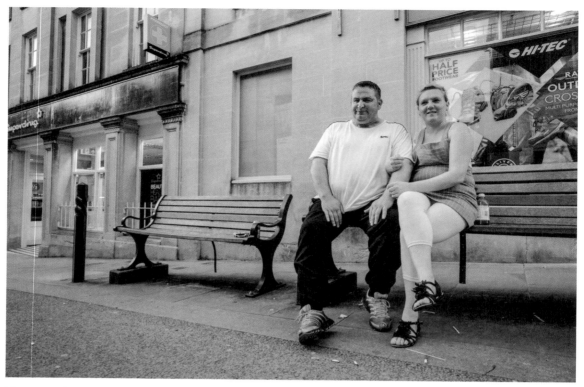

These cuddly, drunk Stroudies were lovely to me. We sat and talked for a while and as the sun got low I took this picture.

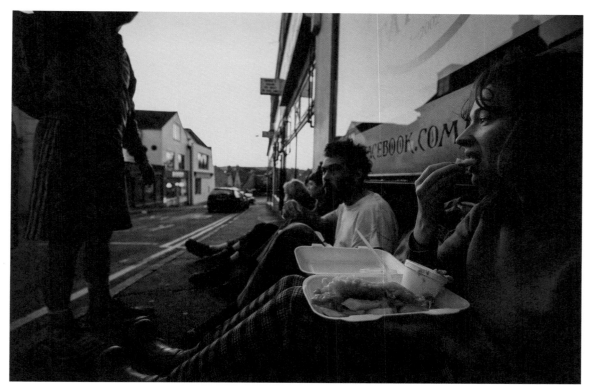

Soaking up some of the day's libations.

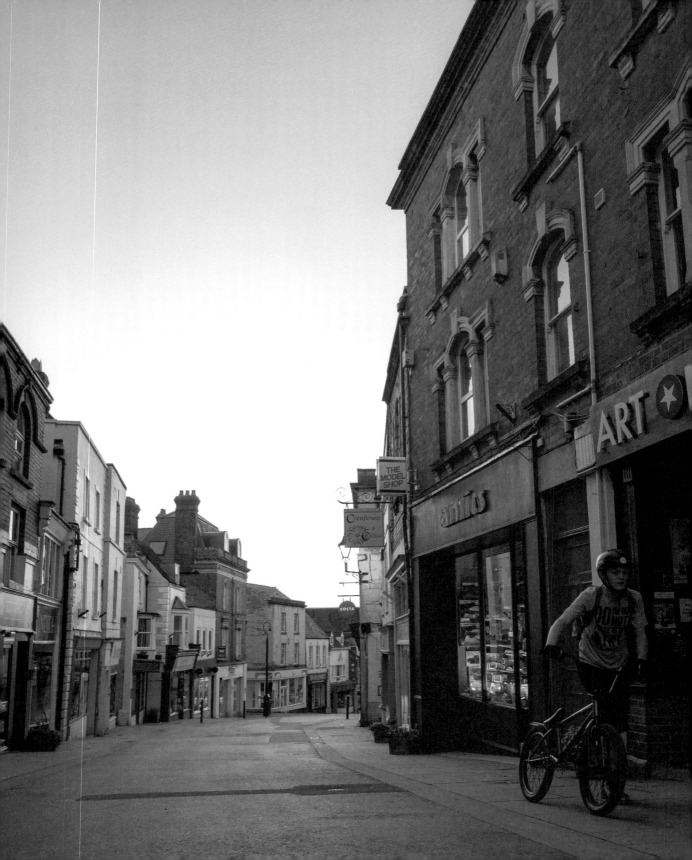

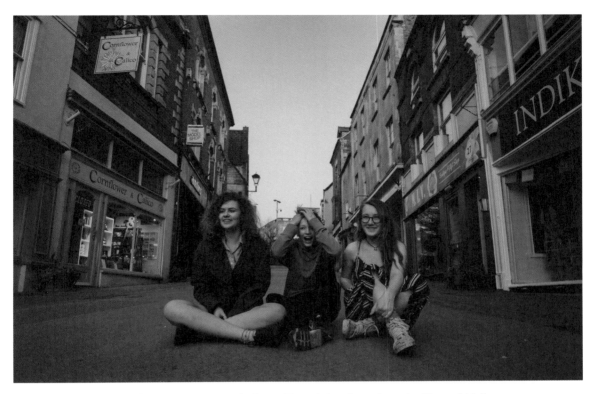

I bumped into these three on my wanderings. They introduced me to Stroud Valleys Art Space, where I met Neil, who introduced me to The Brunel Goods Shed.

Opposite page: I sat on the ground at the top of High Street, looking due west.

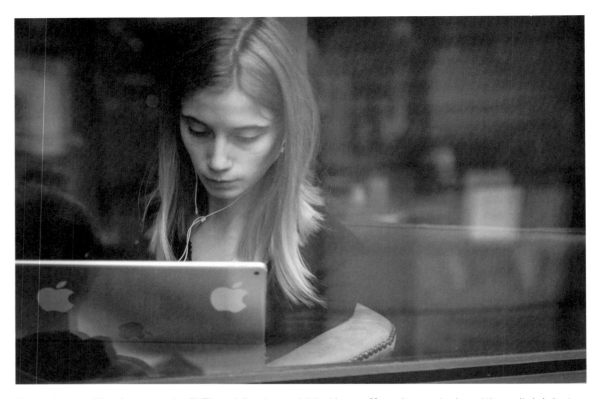

'How do you like them apples?' The obligatory girl-in-the-coffee-shop-window. It's a cliché, but for good reason.

Opposite page: I walked into the centre of Stroud along the canal from Dudbridge Road, past the counterweight bridge, the abandoned rugby pitch and the small industrial buildings. This couple was in front of me for most of the way, holding hands.

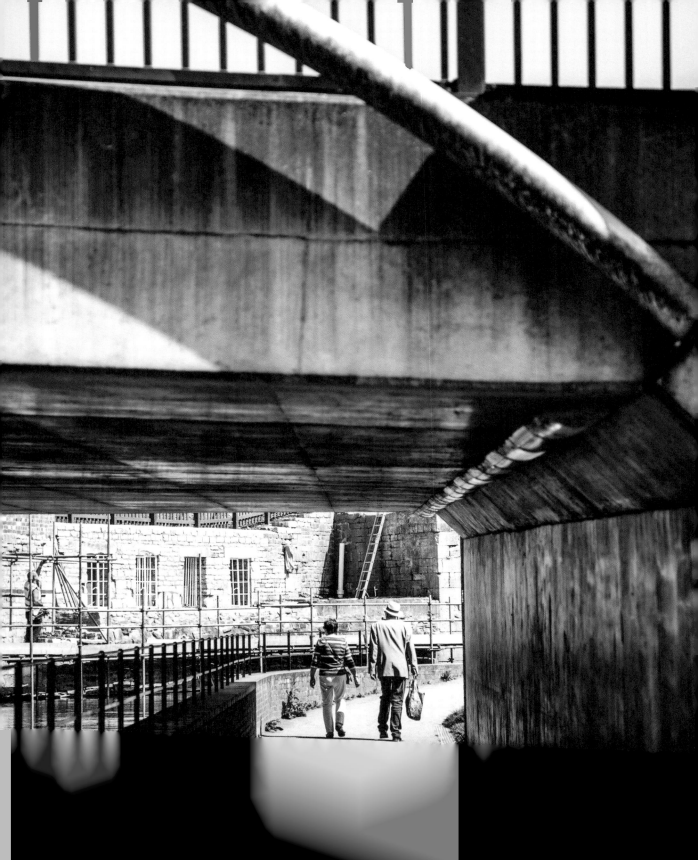

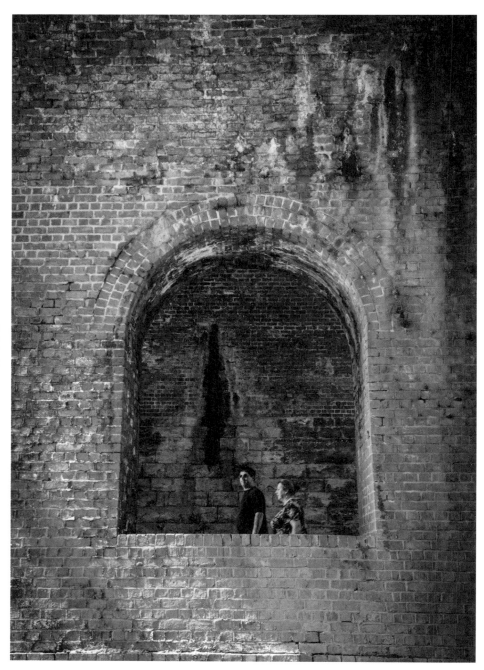

Under the railway arches just past the roundabout, up towards the cinema.
Over the years time paints the Victorian brickwork with all sorts of moss and
fungus. It becomes plant-like, organic.

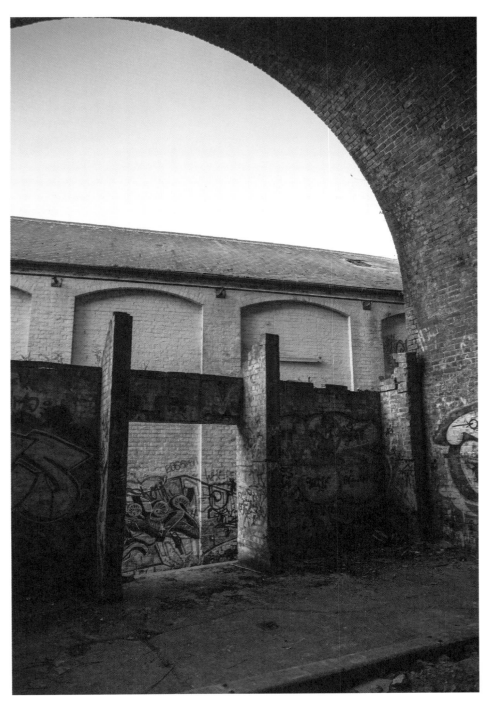

The cave paintings of Stroud.

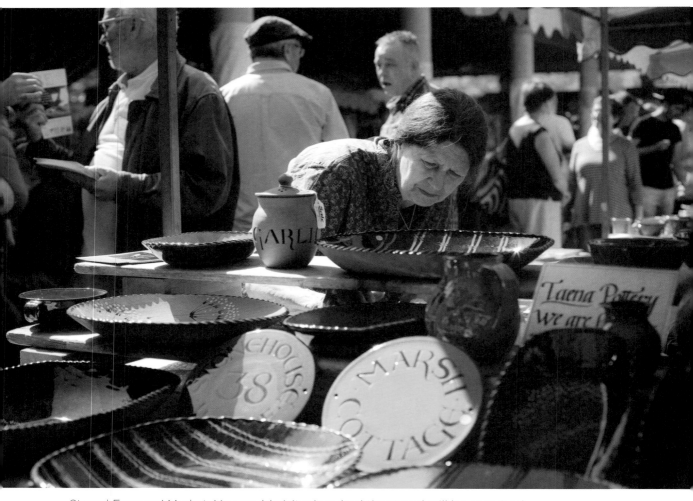

Stroud Farmers' Market. You could visit a hundred times and still be surprised.

Opposite page: the way the light floods the high street gives it such a serene vibe. I love the attic window. This building is full of history, and the guys from Sound Records are selling vinyl there now.

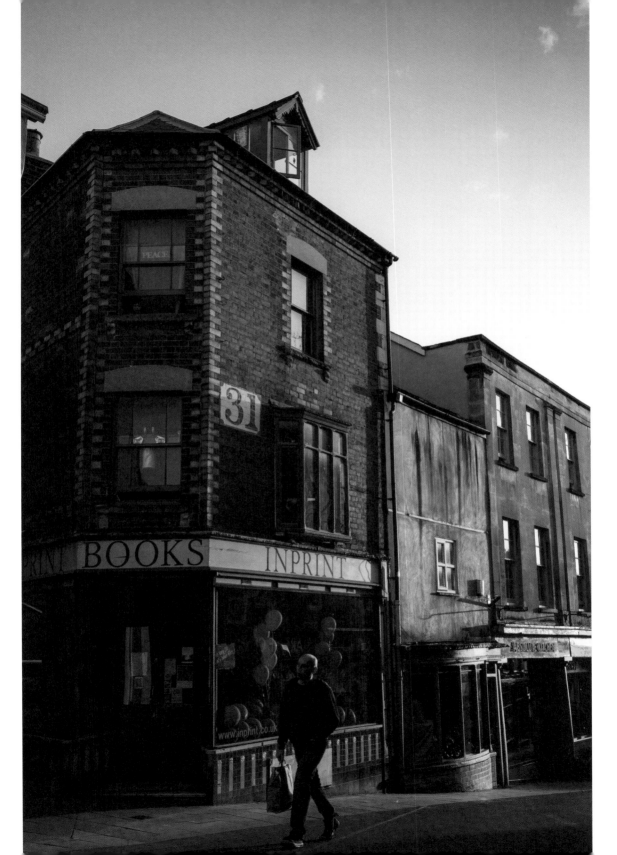

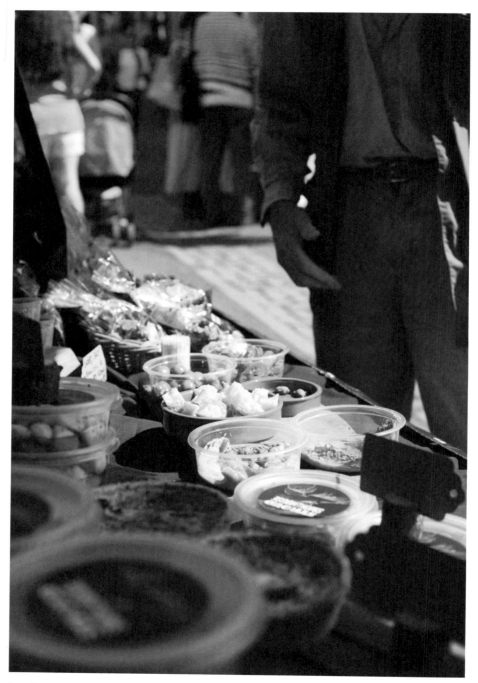

Ian from Stroud Smoke House can pretty much smoke anything edible. I'm a huge fan of his produce.

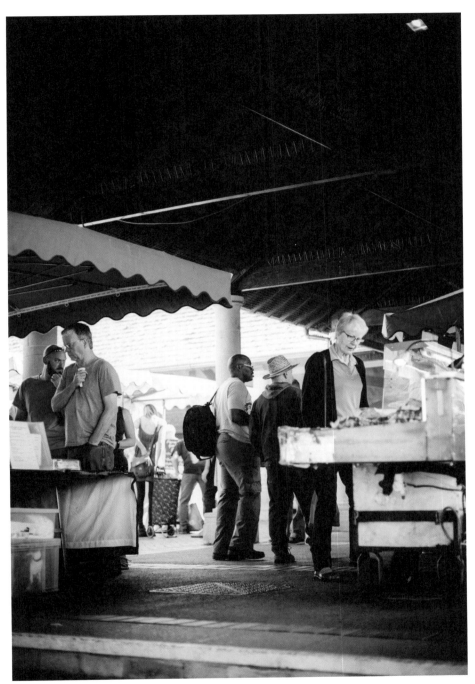

Farmers' market in the square on Union Street.

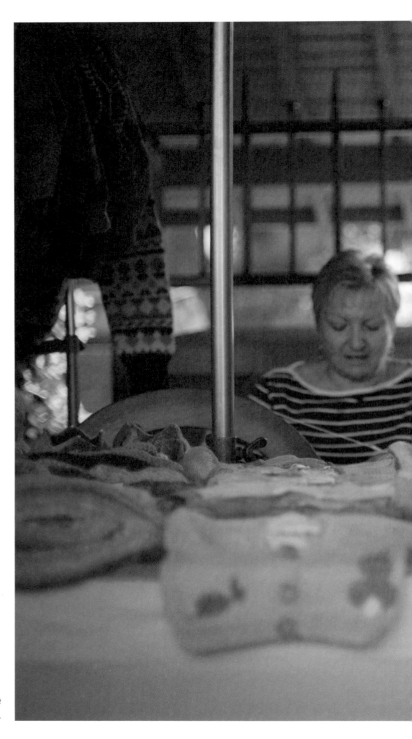

Knitted goods at the
farmers' market.

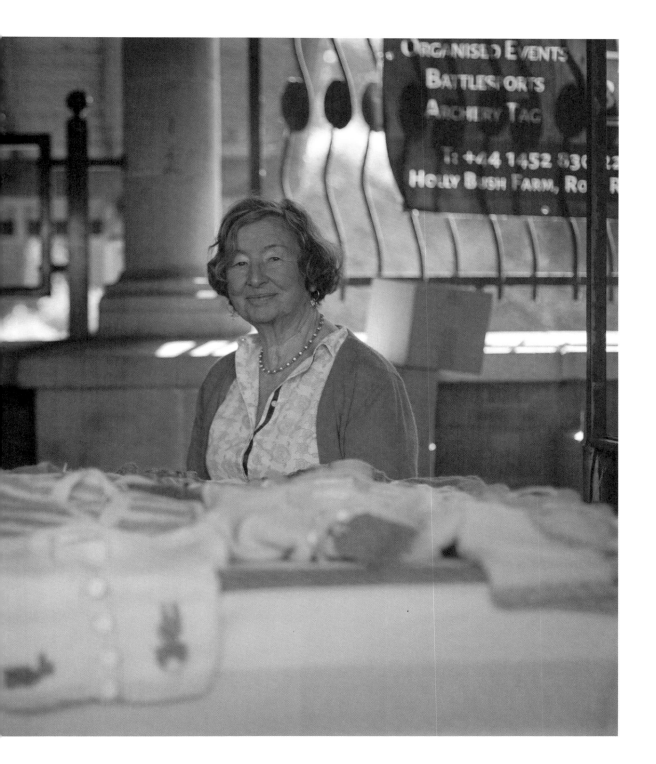

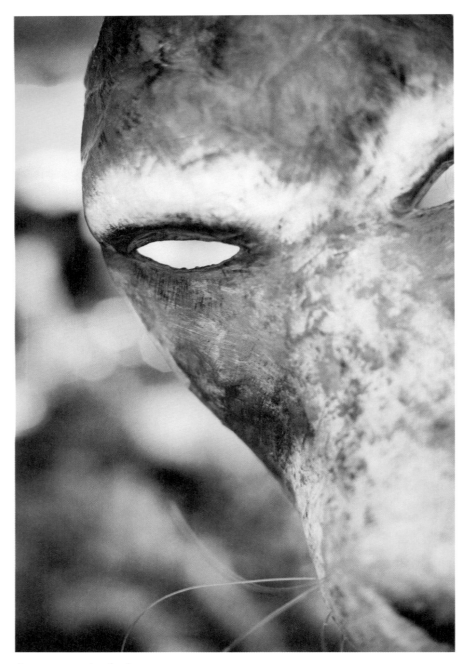

A paper mask of a hare.

Opposite page: spinning wheel.

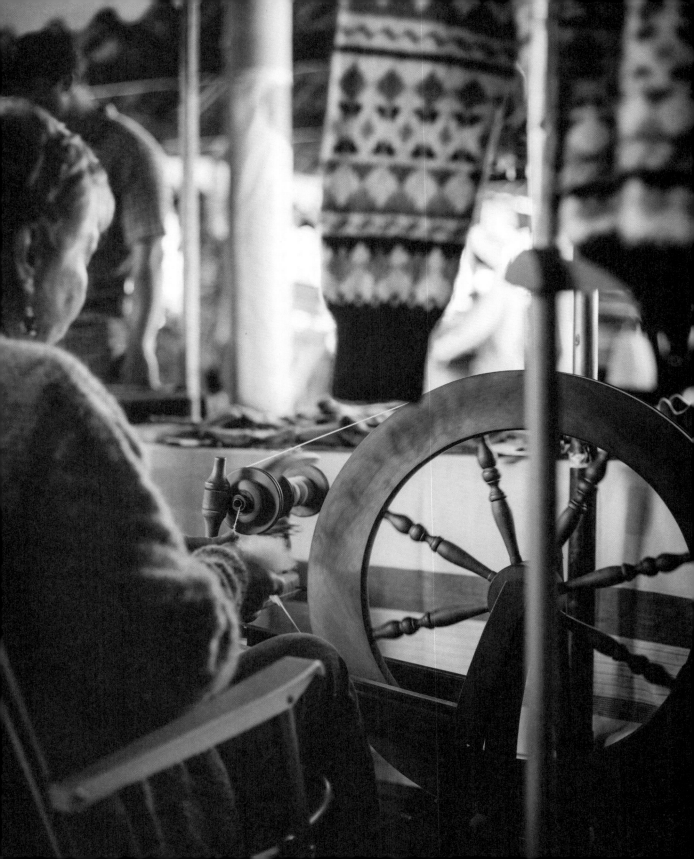

On another of my walks down the canal, I passed these two kids getting fresh. I was with my own kids at the time; their faces were a picture. When we walked back past the spot all we found were four empty cans of strong cider and a pat of vomit. Ah, the impetuosity of youth.

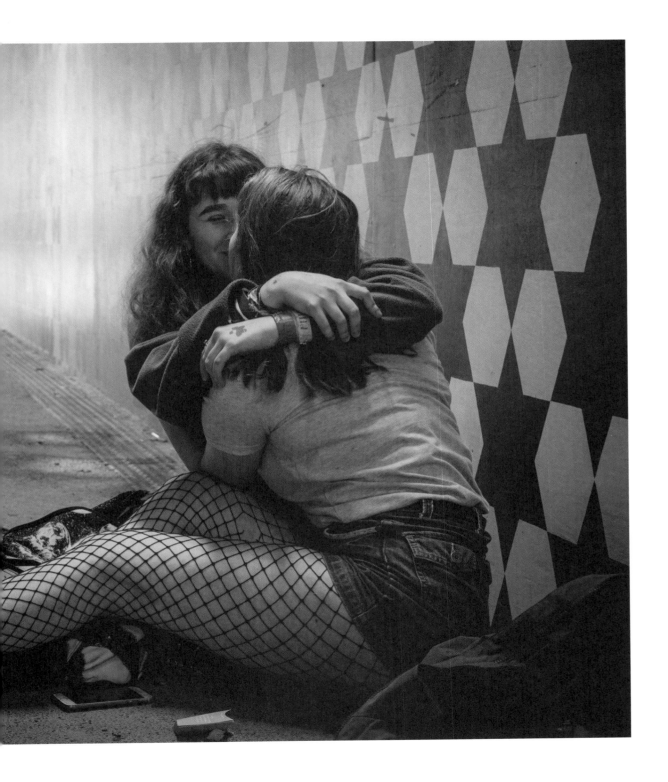

A quick sit down and a cup of tea.

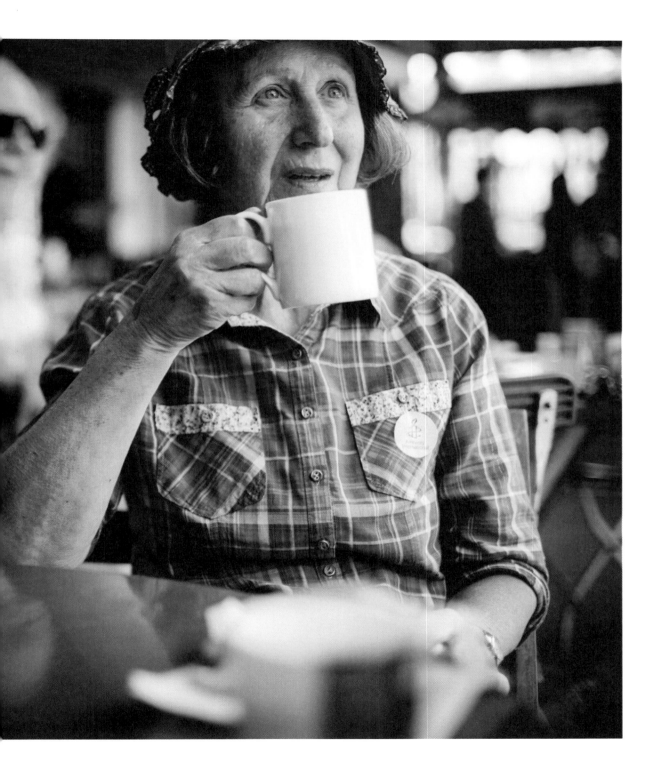

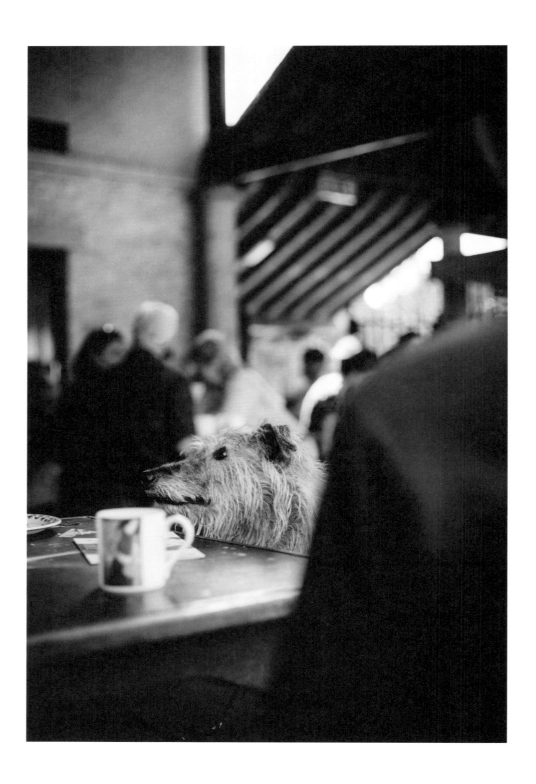

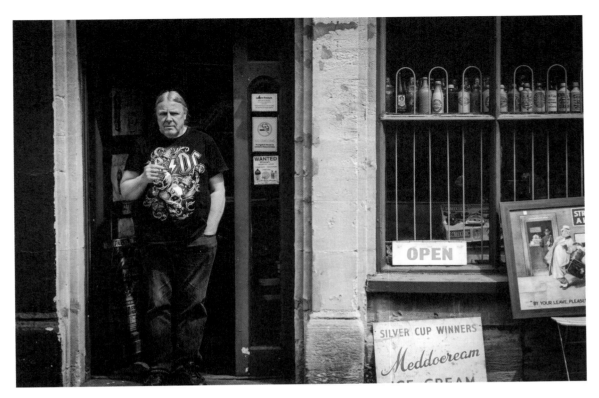

The Collector.

Opposite page: in the square on Union Street they put a few tables out and serve tea and cake at the farmers' market every Saturday. It's the perfect place for me and 'Big' to watch people.

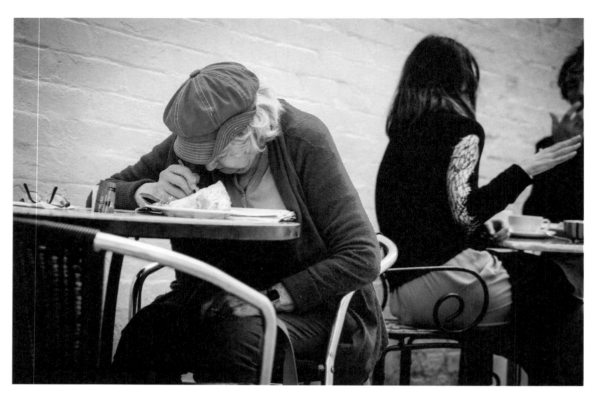

Cake and crossword.

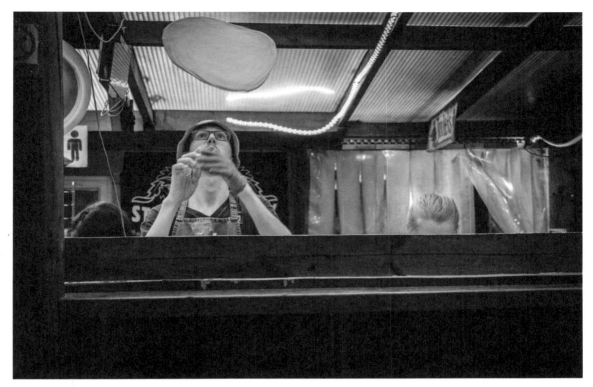

The pizza parlour at Stroud Brewery.

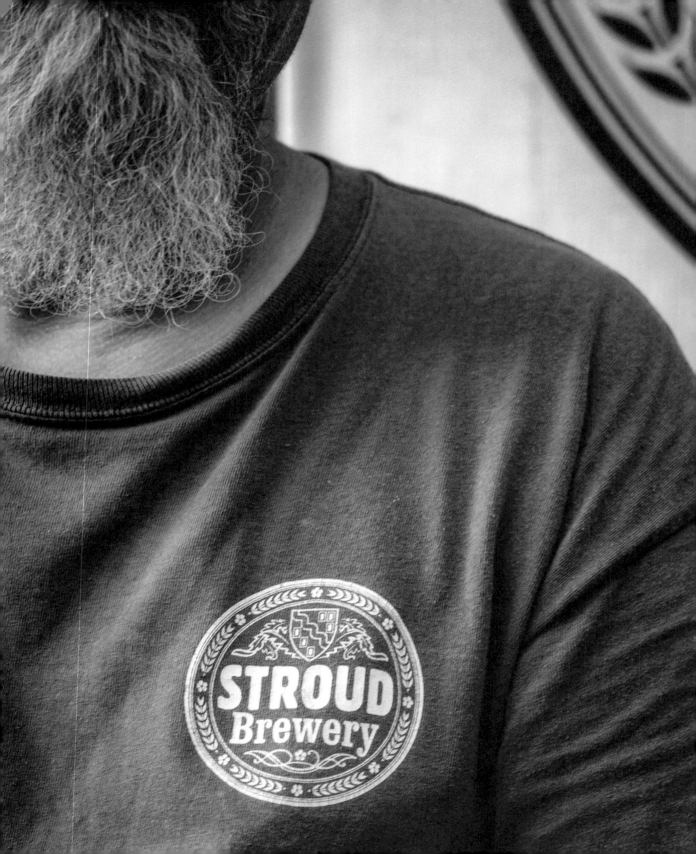

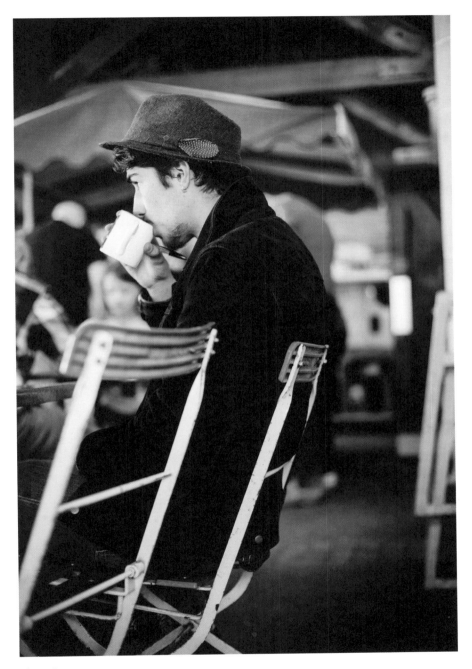

More tea.

Opposite page: Stroud Brewery brewer.

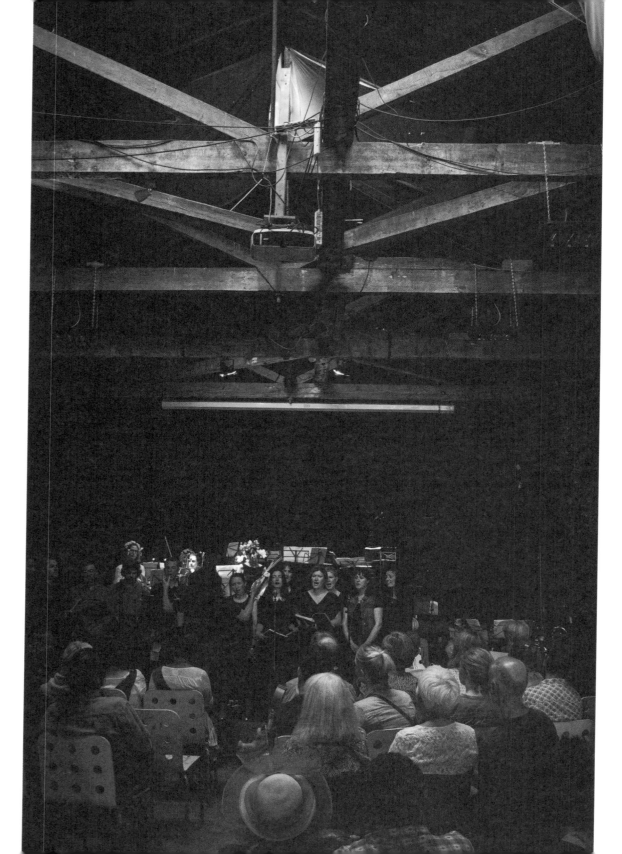

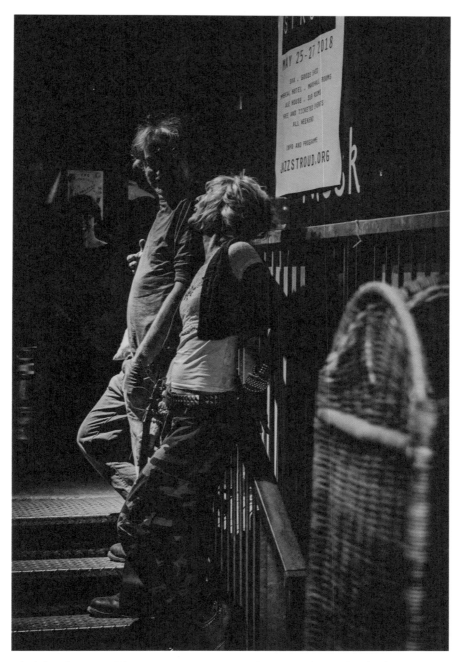

Ukulele player waiting to go on stage at The Brunel Goods Shed.

Opposite page: The Brunel Goods Shed – a cracking venue down by the station that holds a seriously eclectic mix of events.

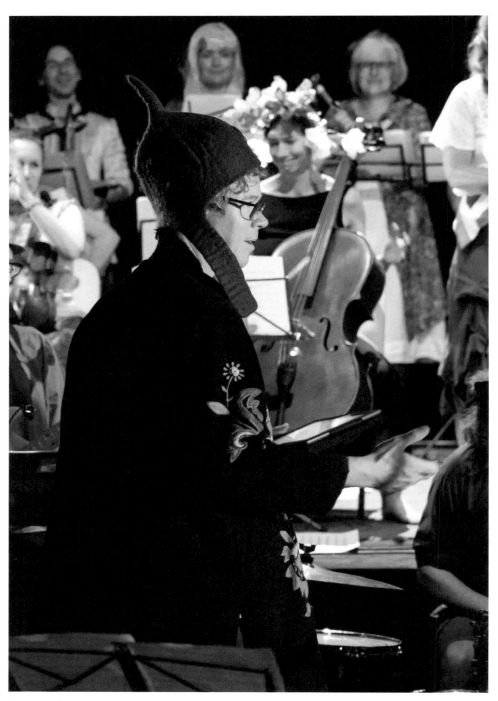

Crazy-talented bunch of musos making some amazing music down by the railway.

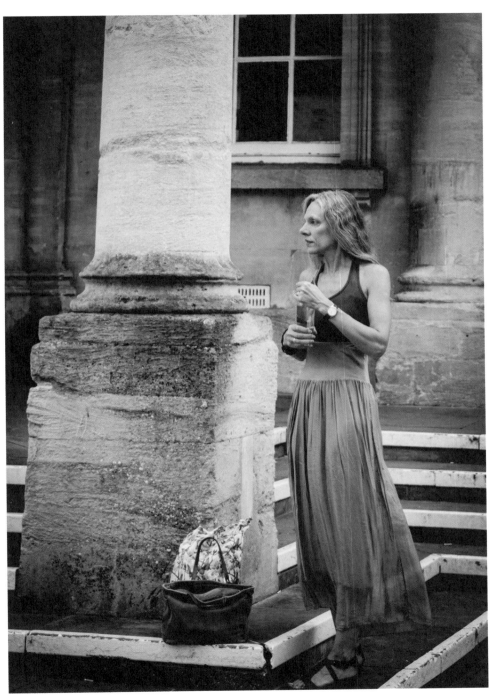

Outside The Subscription Rooms, one of those candid catch your eye moments.

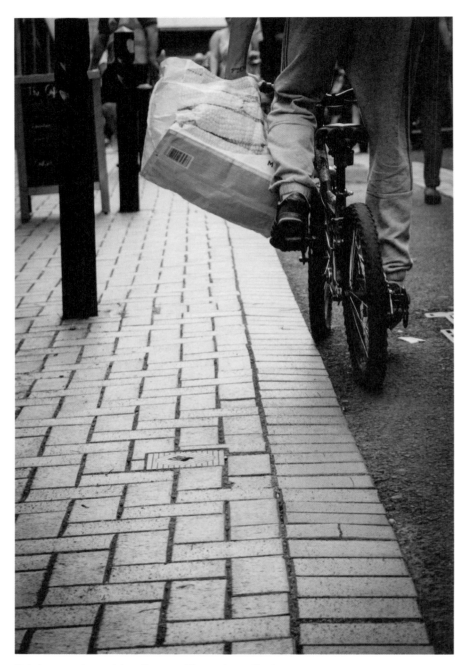

Brick-paved road leading up Threadneedle Street

Opposite page: bright and friendly.

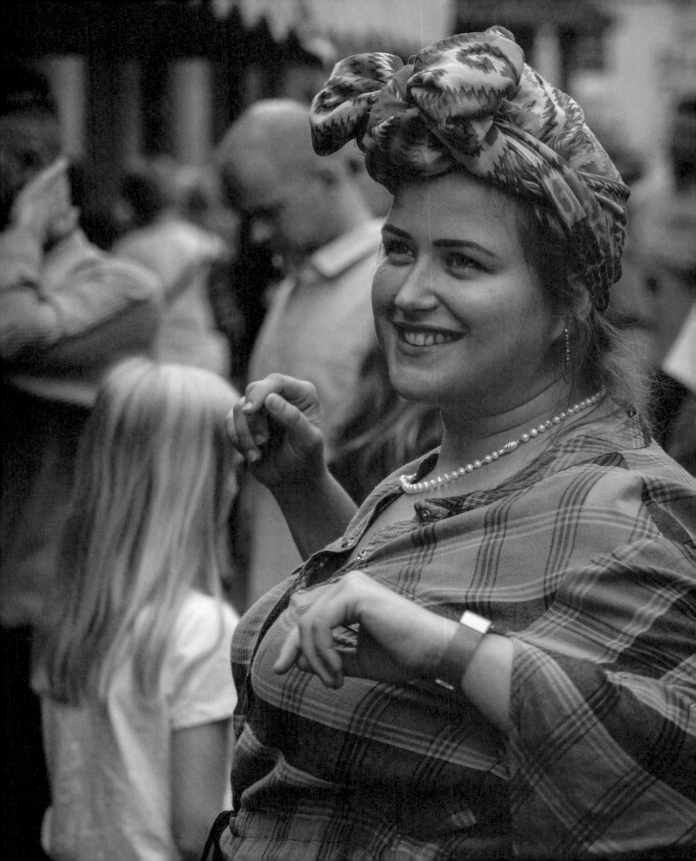

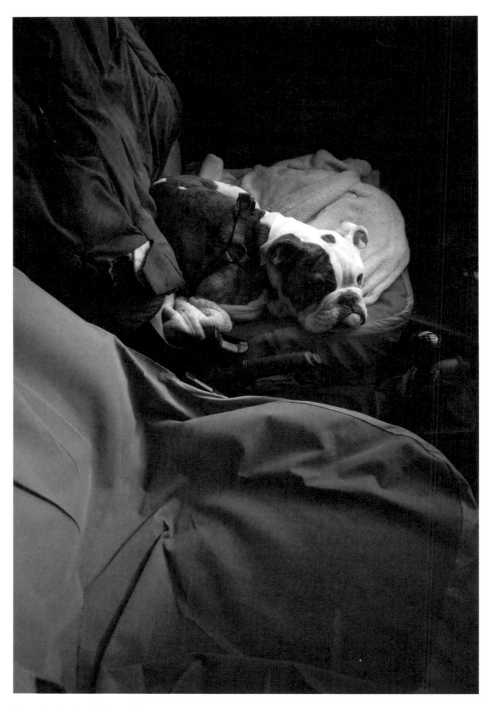

Frank, the builder's dog.

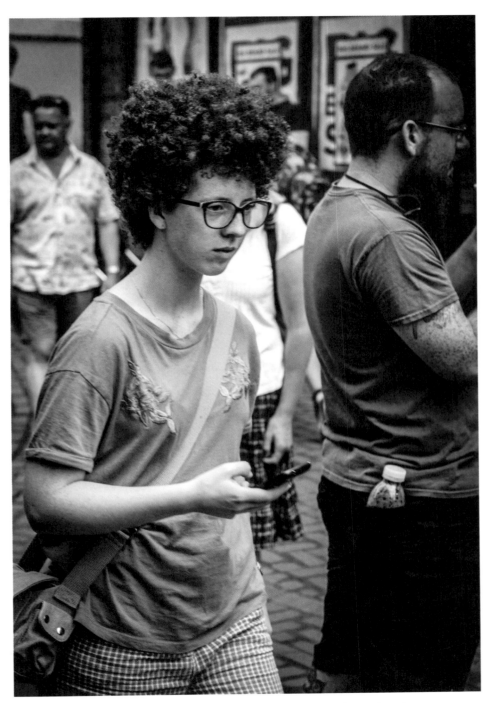

There's something so 'New York, 1976' about her. Apart from the phone.

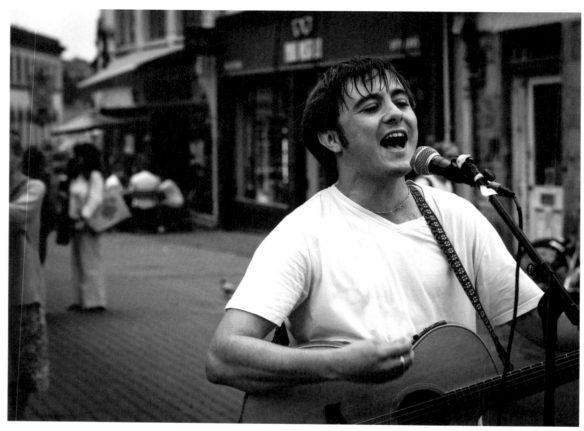

Laurie Wright – his voice really caught my ear.

He sat at the table in the window of the diner on Nelson Street, writing. Two glasses of red wine, untouched until his girlfriend turned up. Their affection was palpable.

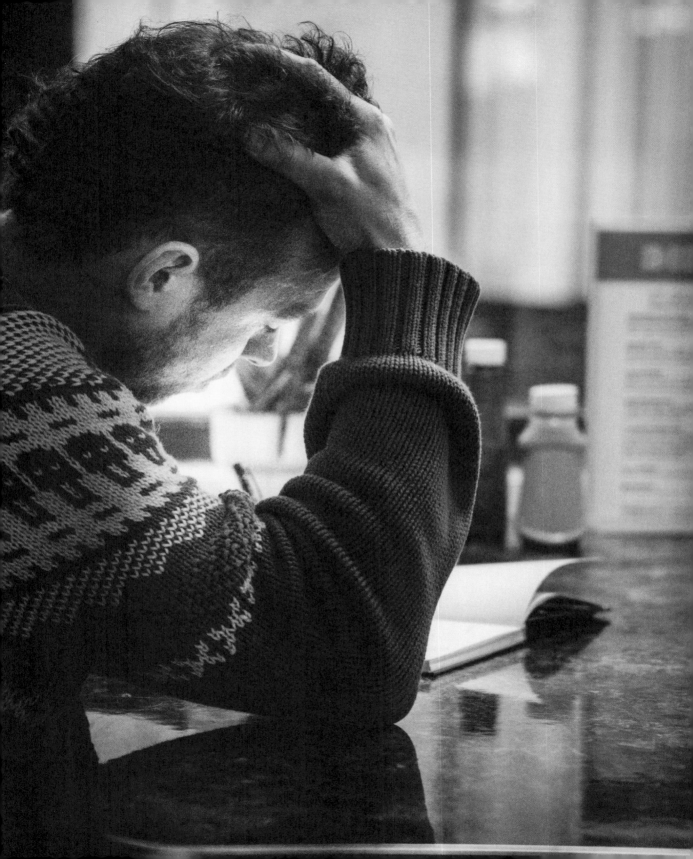

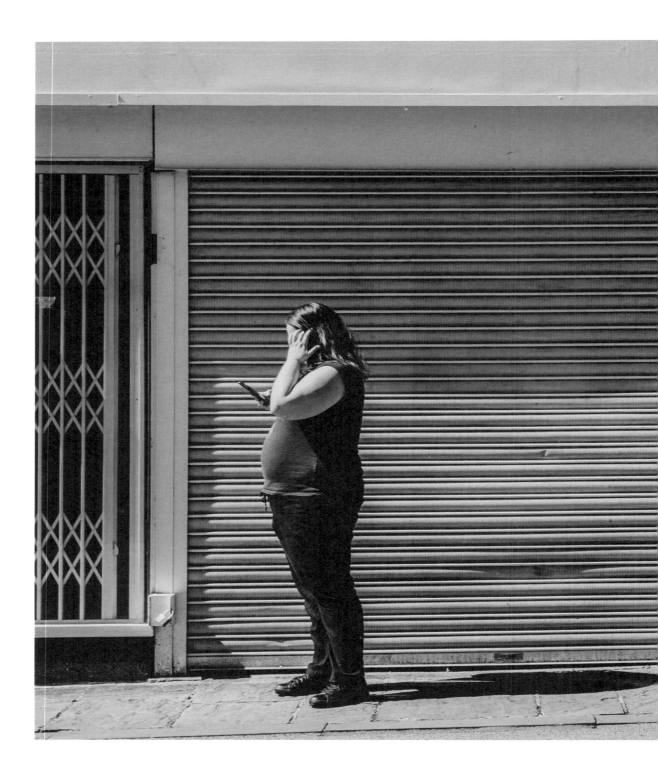

I waited for a good hour for the right moment. Then this happened. I like to find the subtle, visual juxtaposition in the world.

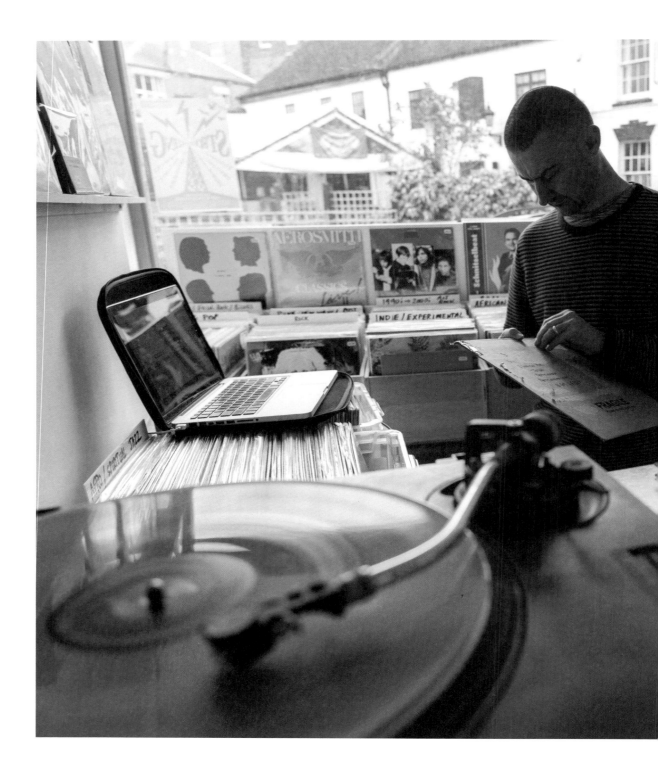

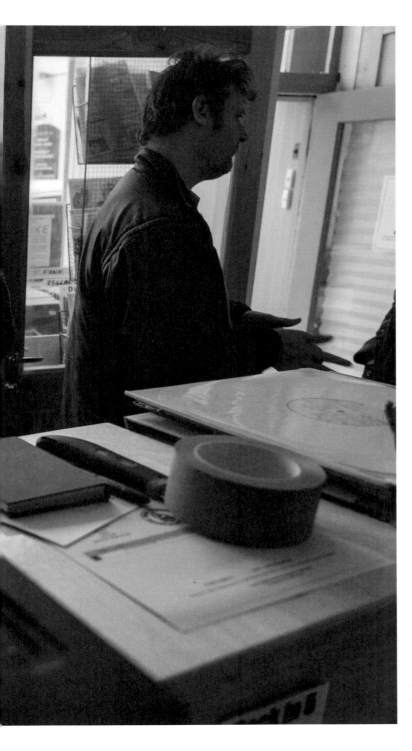

Tom and Sean at Sound Records.
Thom Yorke vinyl on the table.

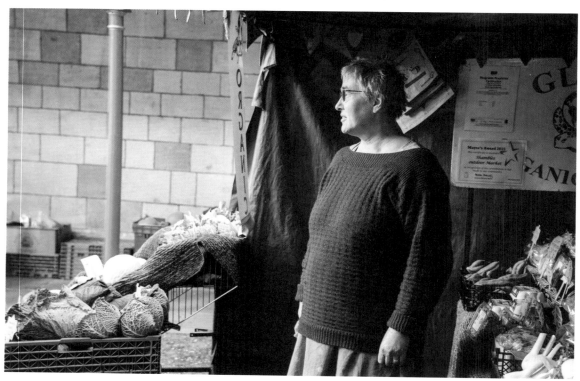

Gilda.

Opposite page: Clover the piano man!

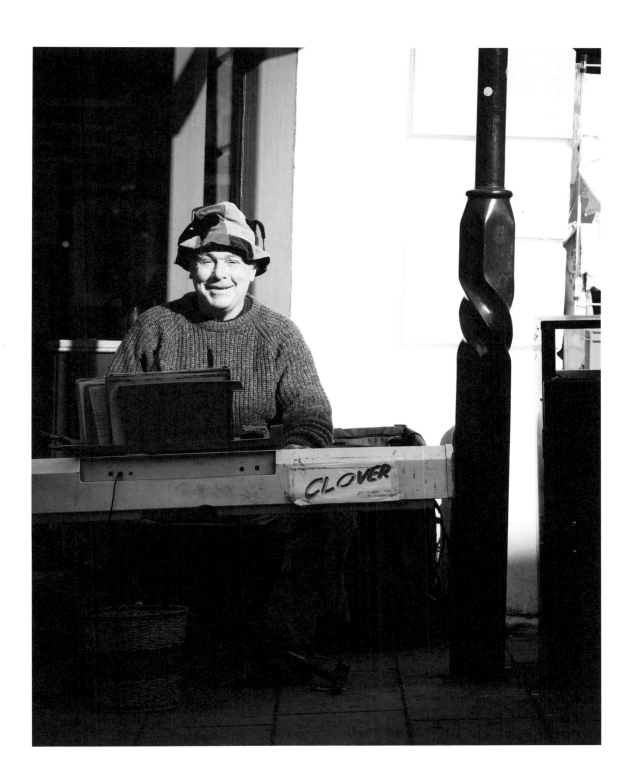

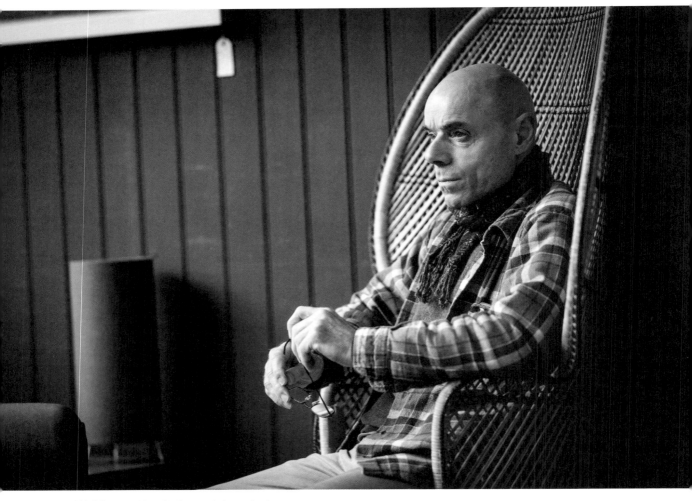

Waiting patiently in a wicker chair.

Opposite page: All Hallows' Eve revision at Black Books Cafe.

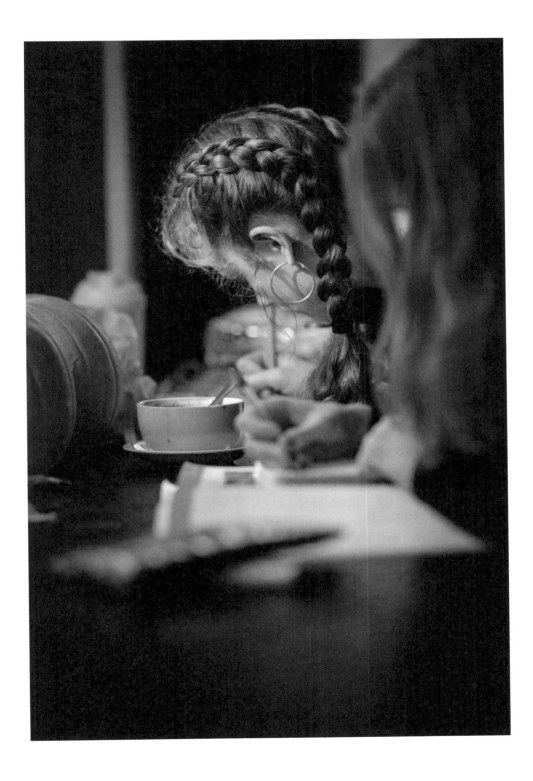

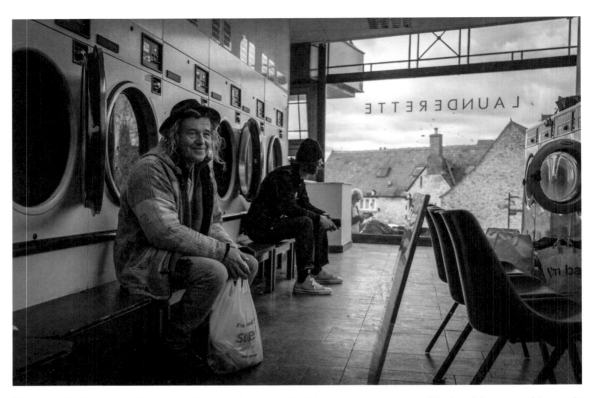

The laundrette opposite the police station. Just behind me, over my right shoulder, was this guy's partner. She was taking a load out of a machine when a pair of her knickers fell at my feet. We laughed.

Opposite page: in the church grounds, just after the rain, I saw this lady walking along the path and the colours were fab! I yelped to get her attention and she was none too pleased, as you can tell. We talked afterwards and I showed her the shot. She was lovely and chuckled as we parted.

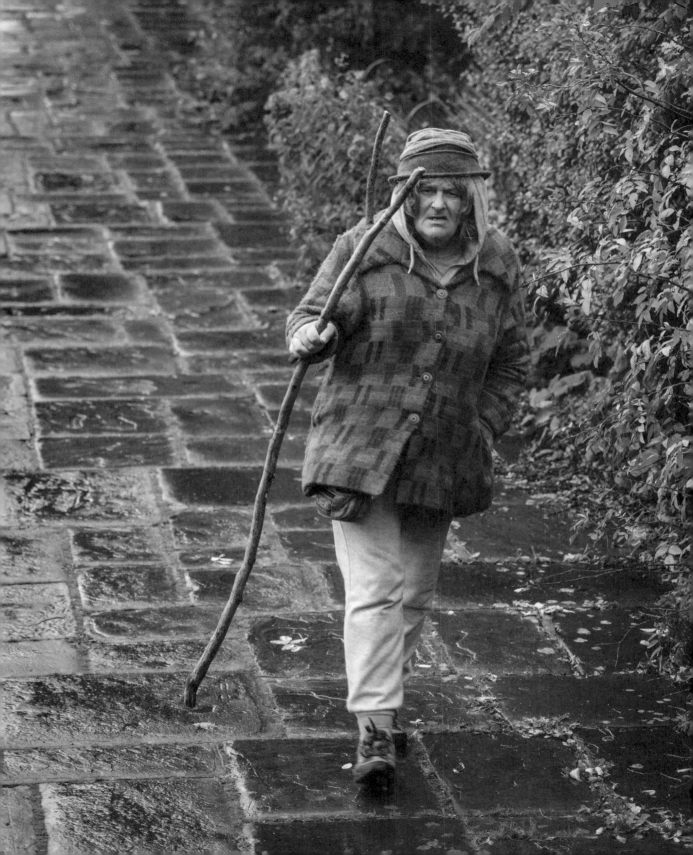

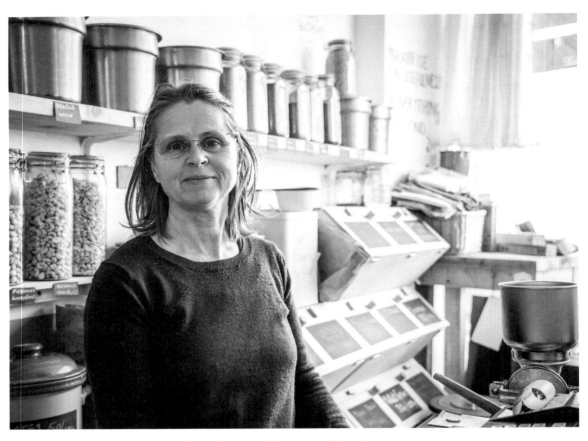

Julie of Loose, the packaging-free shop on Gloucester Street.

Opposite page: mum and daughter in the Stroud Diner, now closed, on Nelson Street. Mum had just asked a maths question and the way the daughter was holding her ice cream in concentration caught my eye.

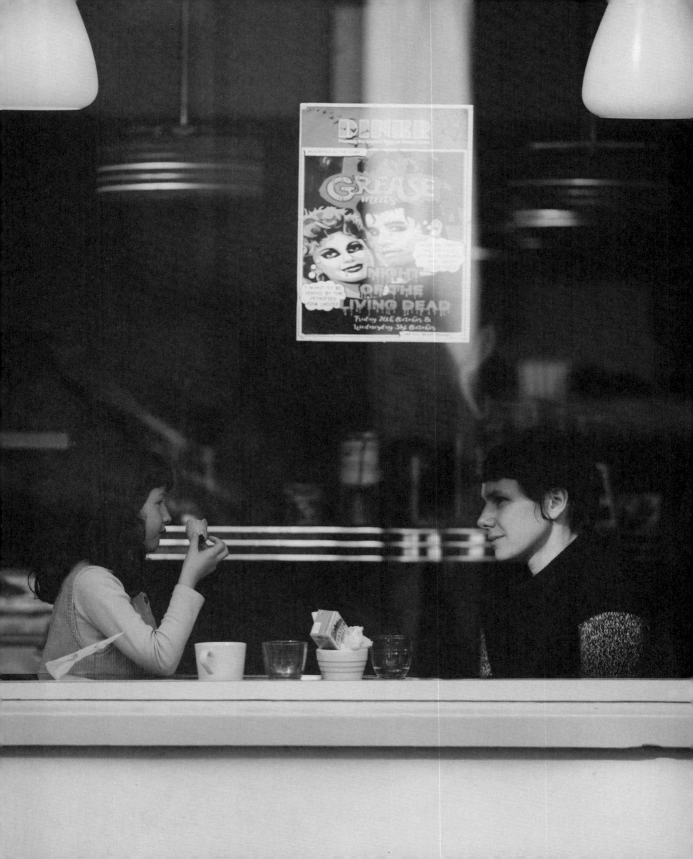

The walkway spanning the A46.

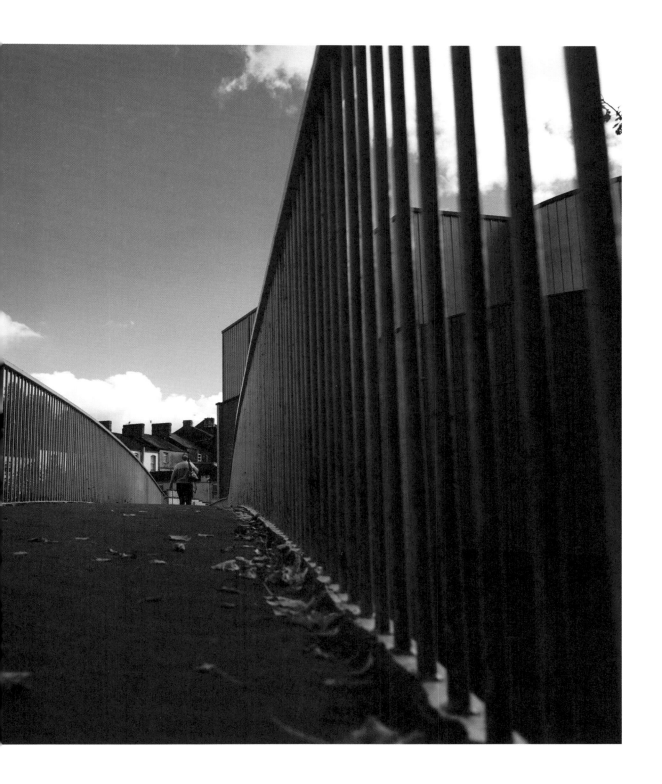

Sean from the record shop sitting
in the café at Stroud Valleys
Art Space. Damn nice coffee.

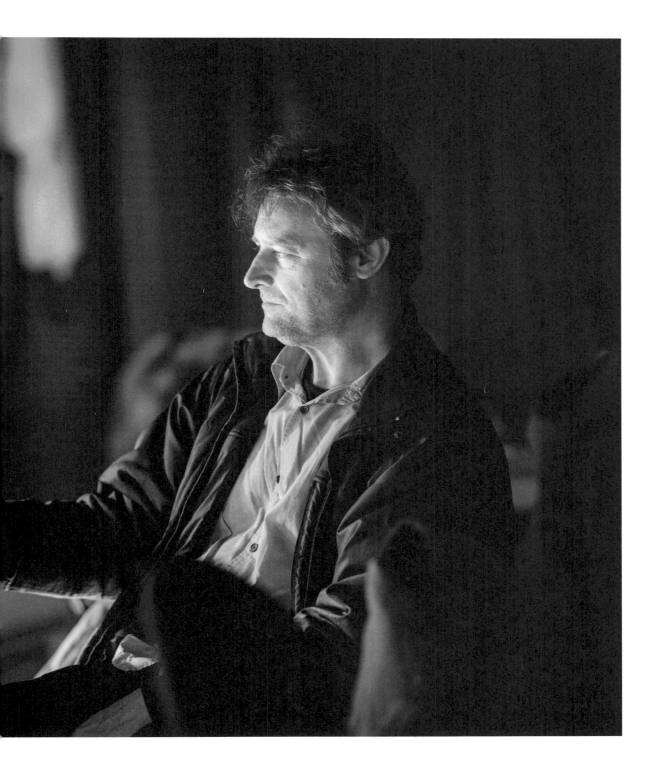

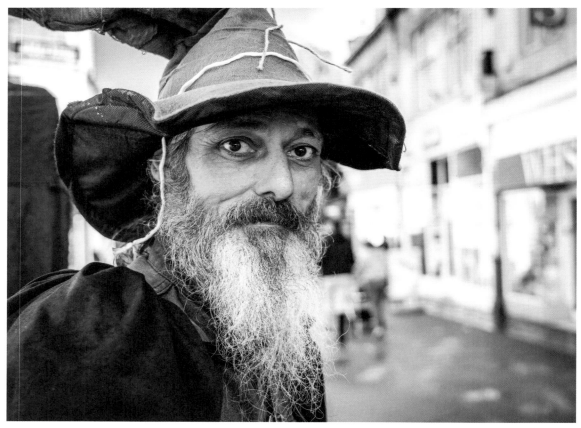

Stroud wizard, Terry. He campaigns for the unlucky and downtrodden, asking that empty homes be occupied by the homeless. Every system has a cycle and this one has run its course.

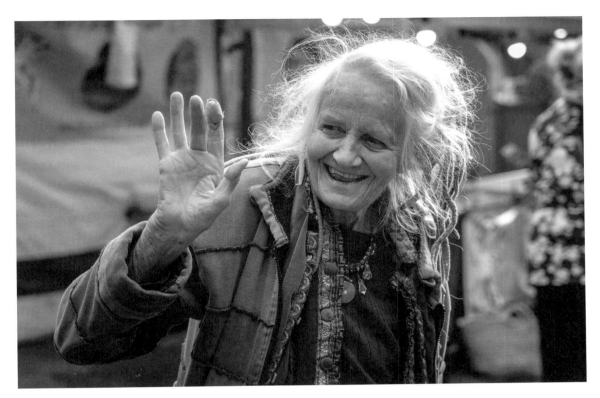

Sanita.

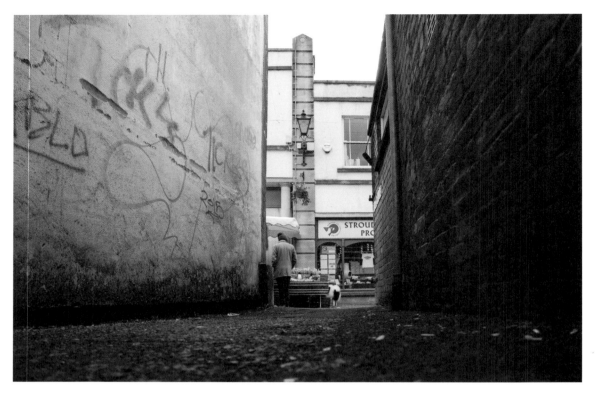

The small passageway running between John Street and Threadneedle Street.

Opposite page: a scene often associated with Stroud because of its urban/countryside connections.

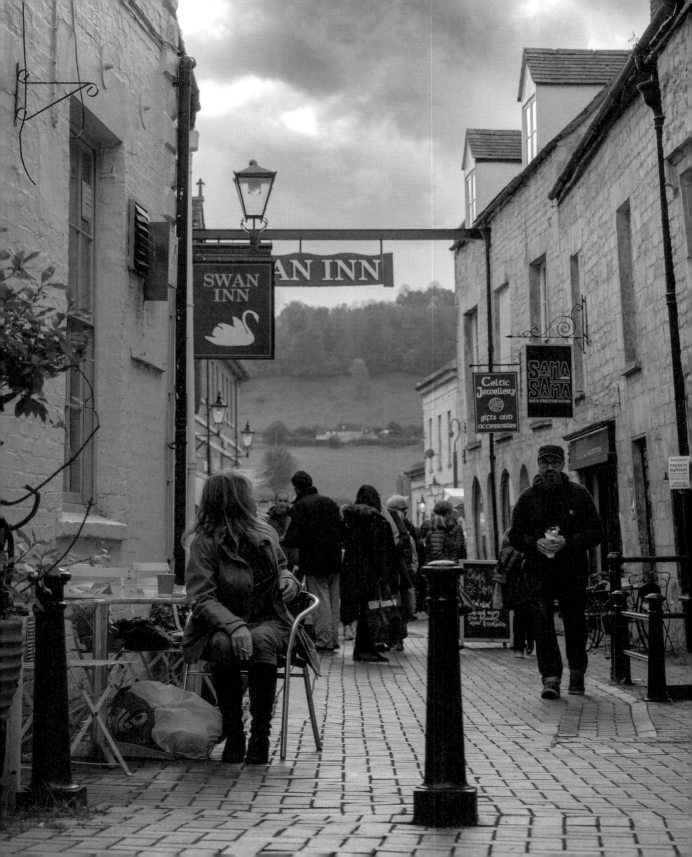

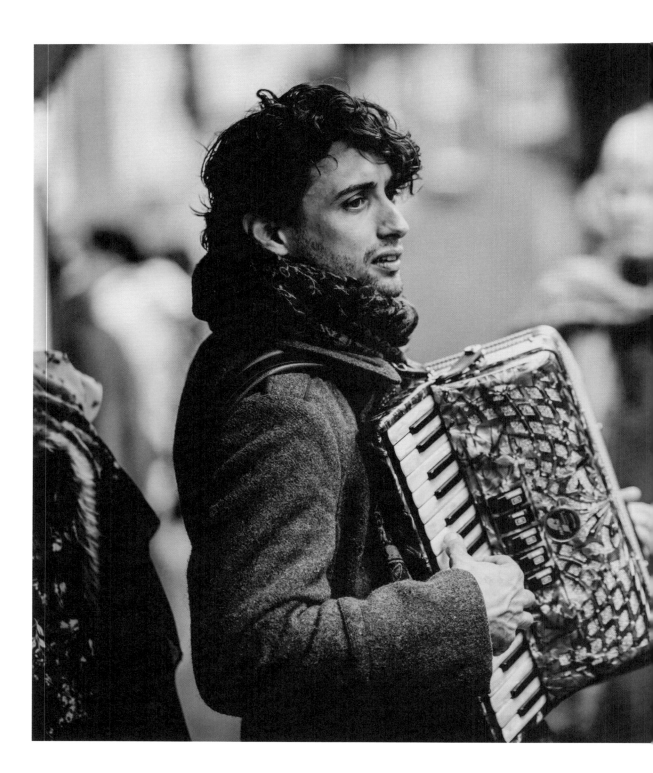

Jaz Delorean.

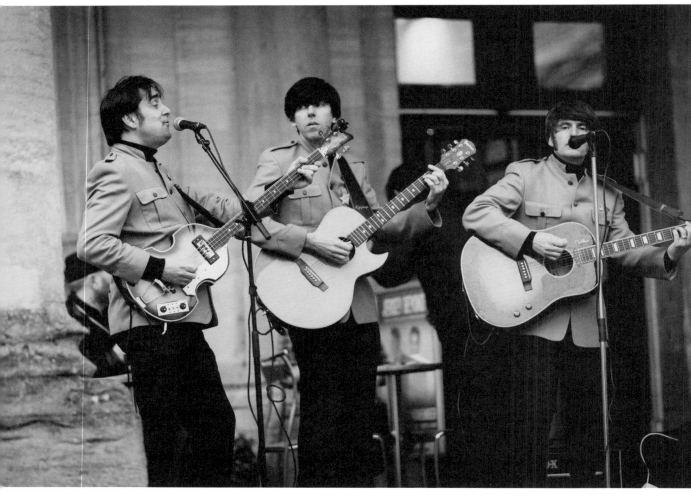

The Ringo-less Beatles.

Opposite page: the walkway crossing the A46. You find a spot and sit for a while, waiting for moments.

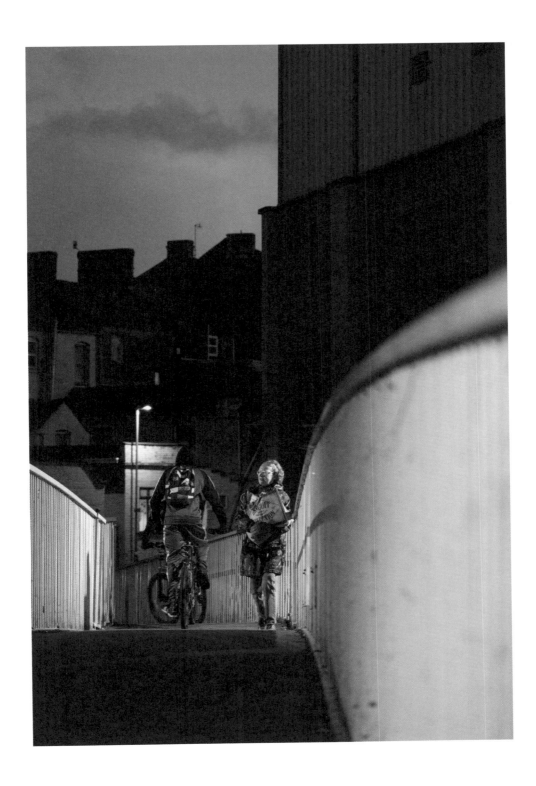

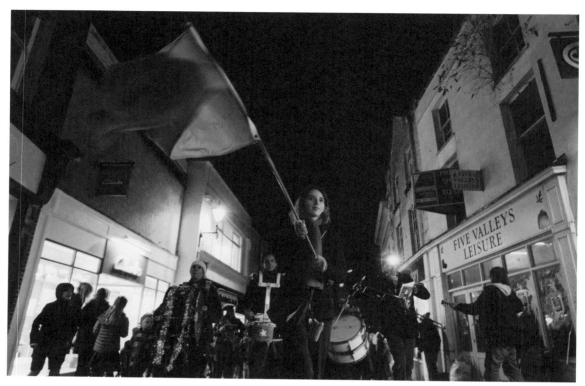

Christmas parade or revolution? I hope it's the latter.

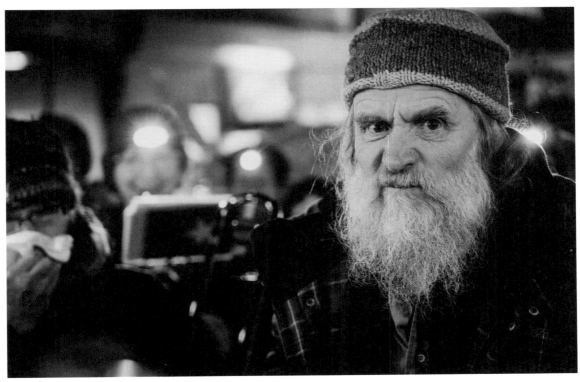

I've met this lovely man a few times since I took this shot. He's proper nice and doesn't hate photographers at all.

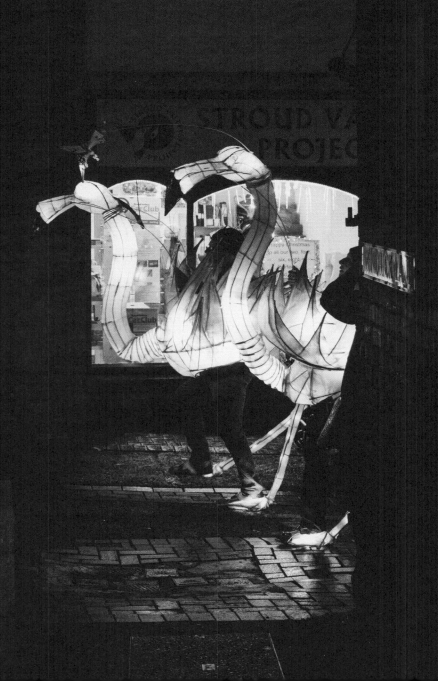

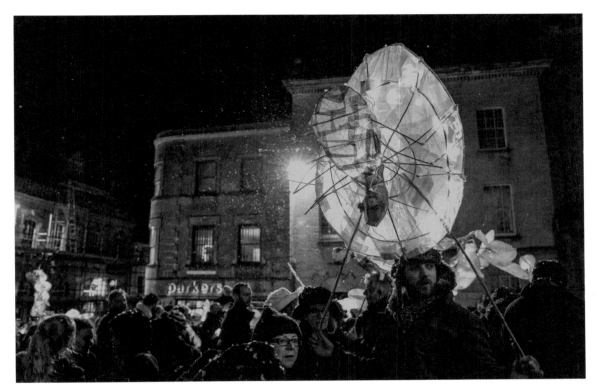

In the depths of winter, folks gather and parade the streets of Stroud to welcome Christmas. This year the organisers installed a snow machine on the balcony of The Subscription Rooms, where the revellers gathered.

Opposite page: strange night creatures stalking the streets. I managed to duck down an alleyway and lose them in the hubbub.

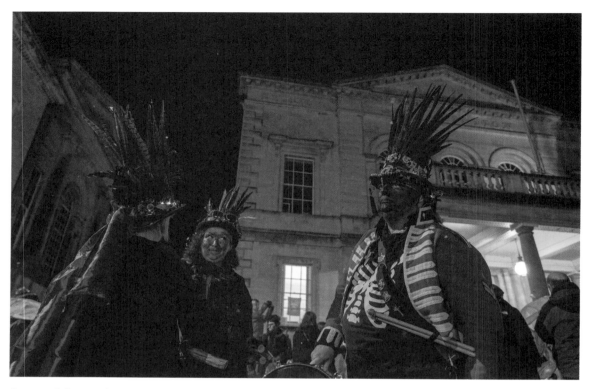

Some of the performers dressed in their Wassail gabardine. A test run, perhaps, to soften the January blow?

Opposite page: in all the chaos of the Christmas parade, this gentleman caught my eye as he meticulously prepared his bike in readiness for his journey, oblivious to the spectacle around him.

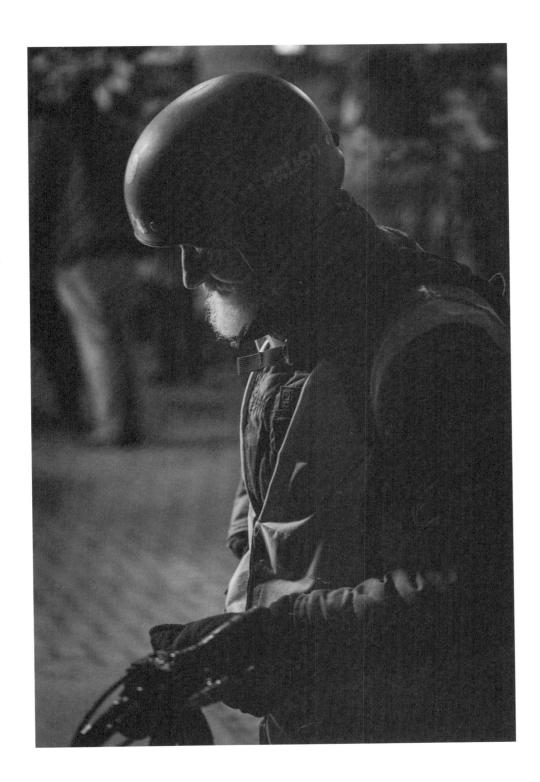

Dogs rarely stare into a camera with such intensity. The bag is very Stroud and it's all very cute, but what struck me was the look right through the camera.

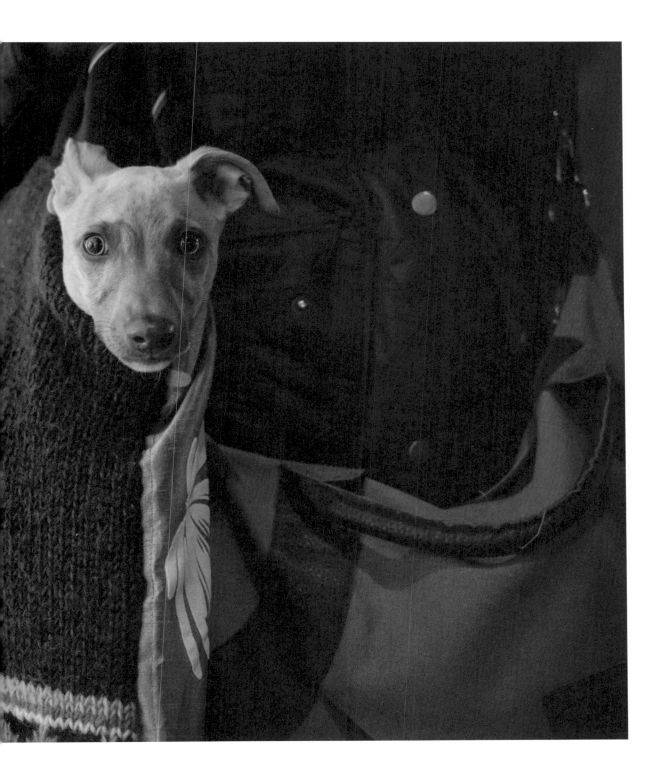

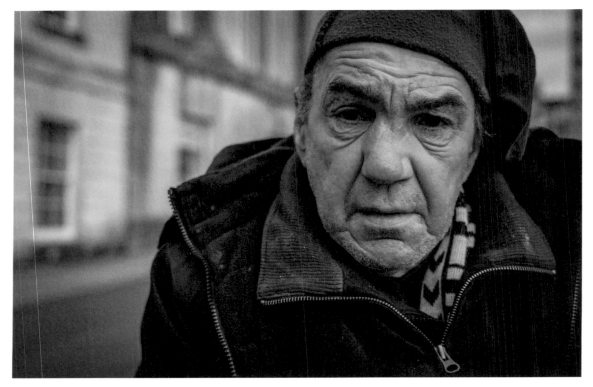

Some of you may know this man. I've seen him a few times with can in hand.

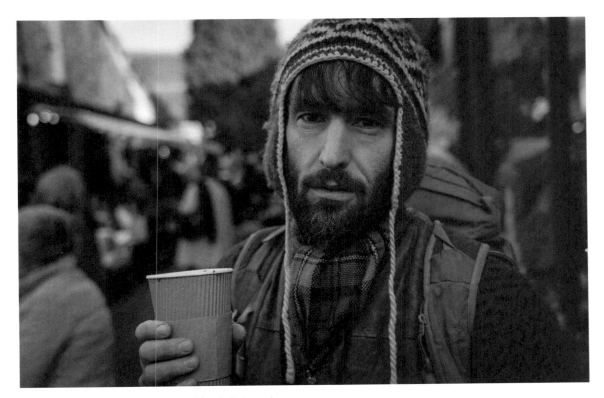

Rupert Burdock. I asked him if he felt loved.

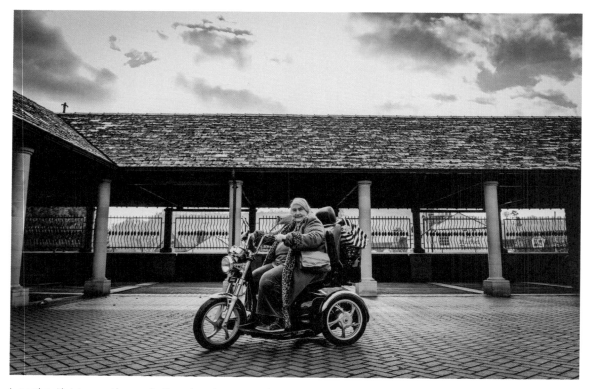

Local artist tears through the streets at an alarming pace and challenges pedestrians often.

Opposite page: the Wassail in January. A festival that was revived back in 2014 and has grown at a pace ever since. The message is 'have a healthy year'.

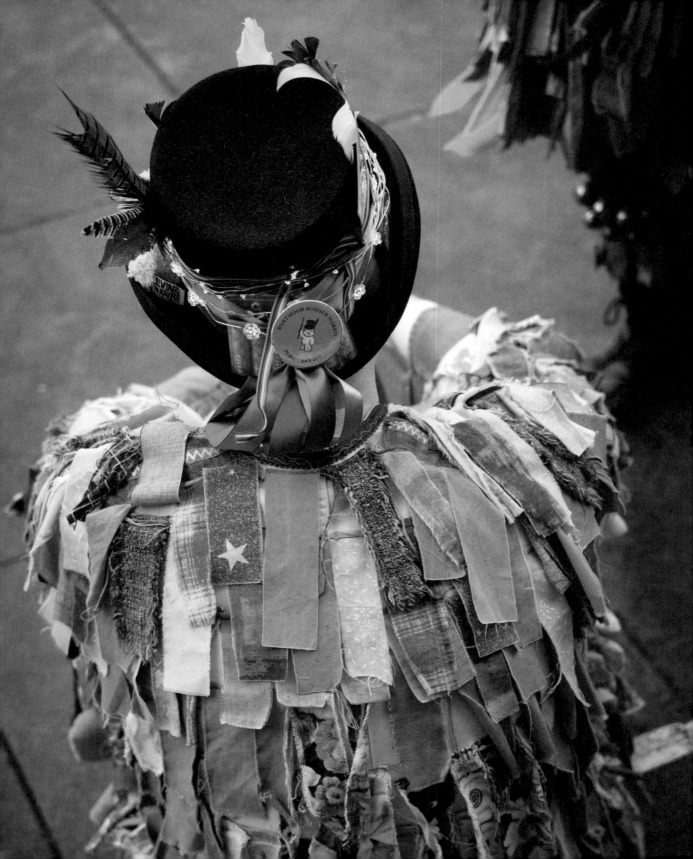

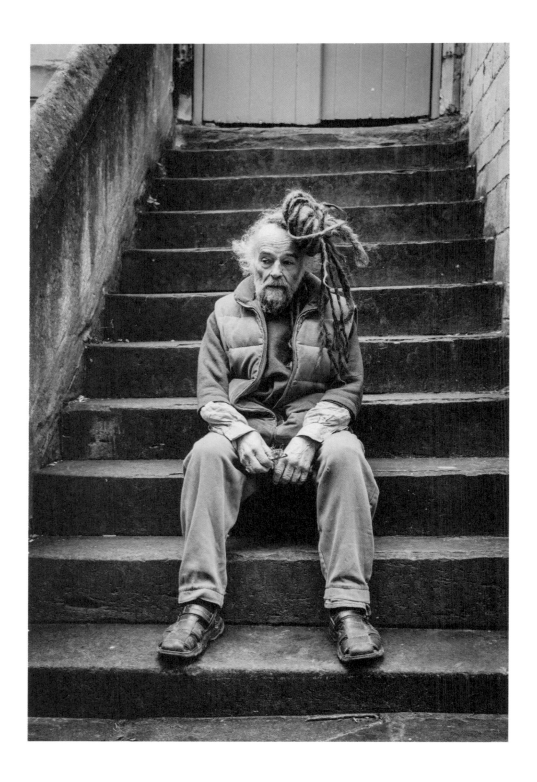

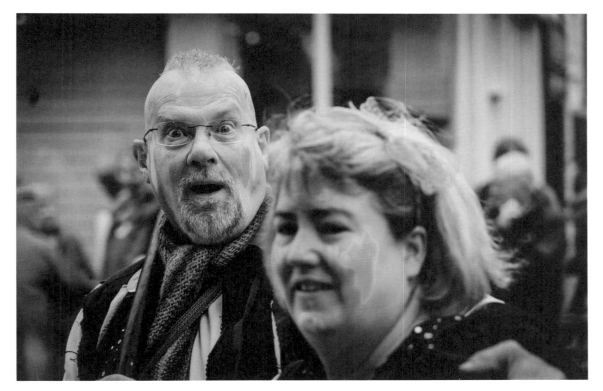

Wassail in neon.

Opposite page: on the steps.

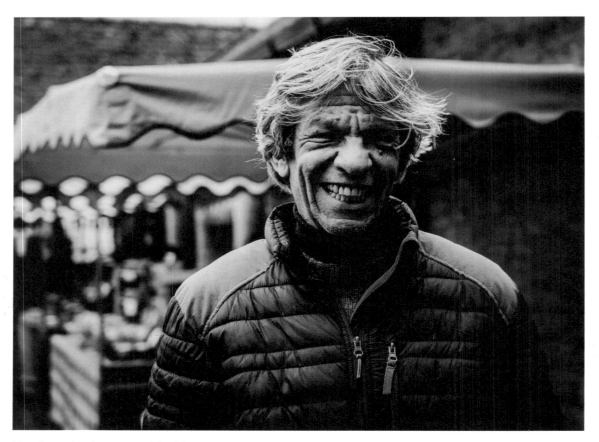

Kardien, also known as 'Gerb'.

Opposite page: splitting hairs.

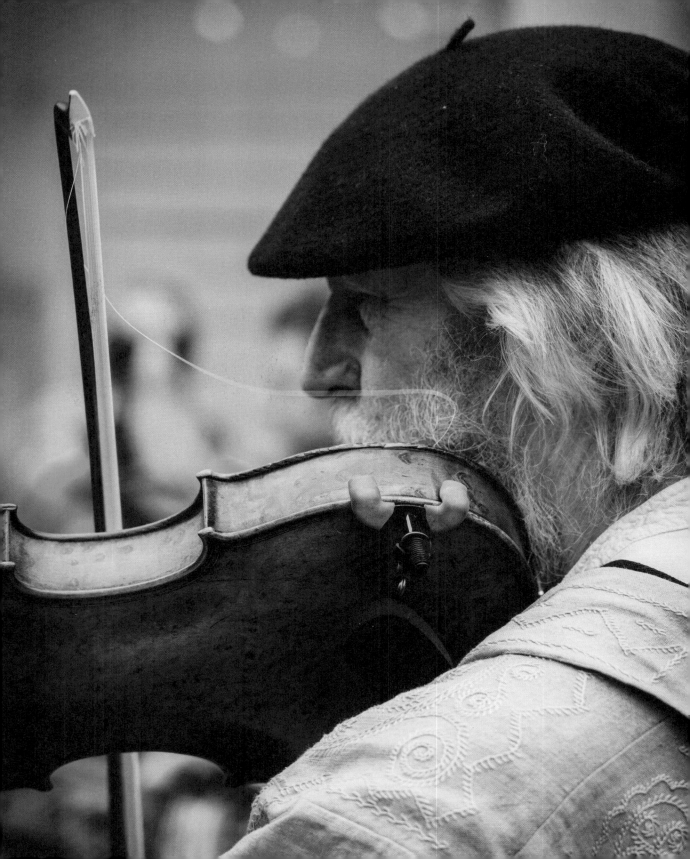

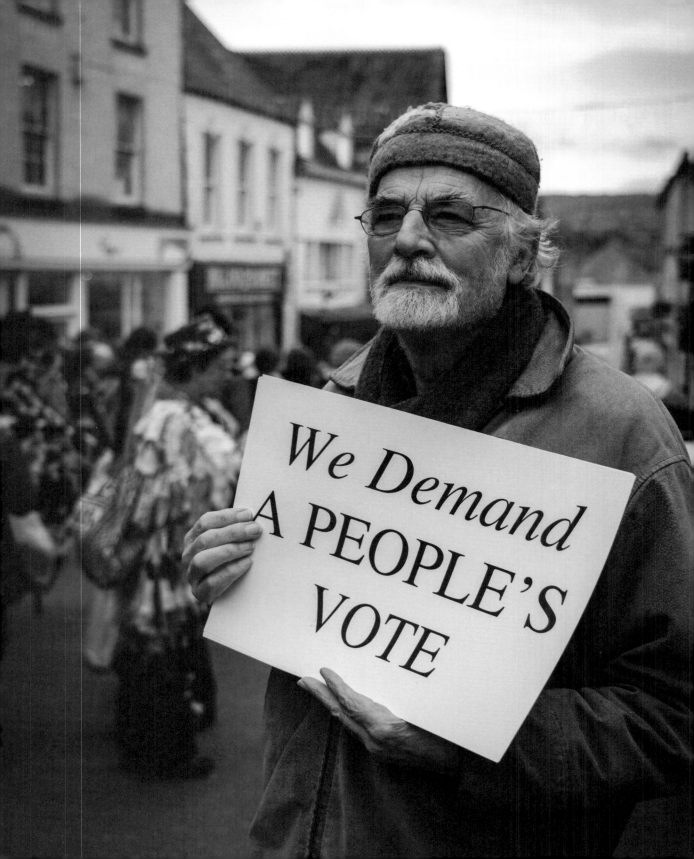

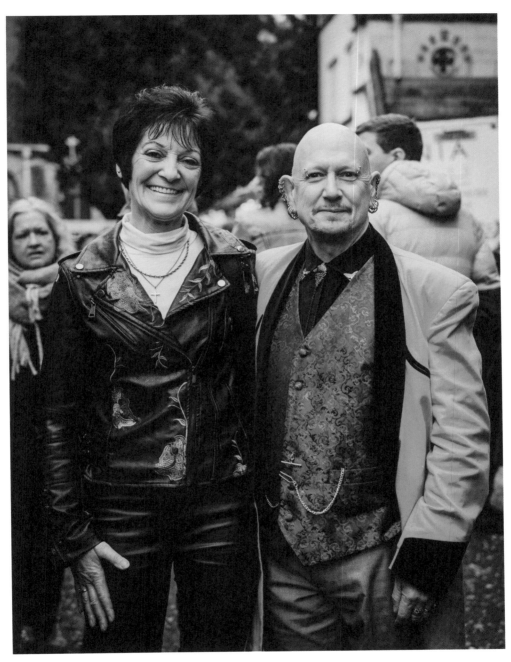

Colourful characters abound.

Opposite page: the unwinding of the democratic process, or political petulance?

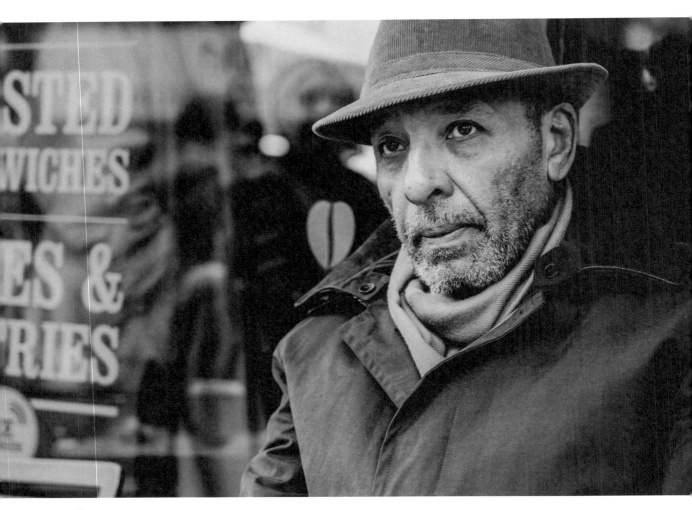

Theo.

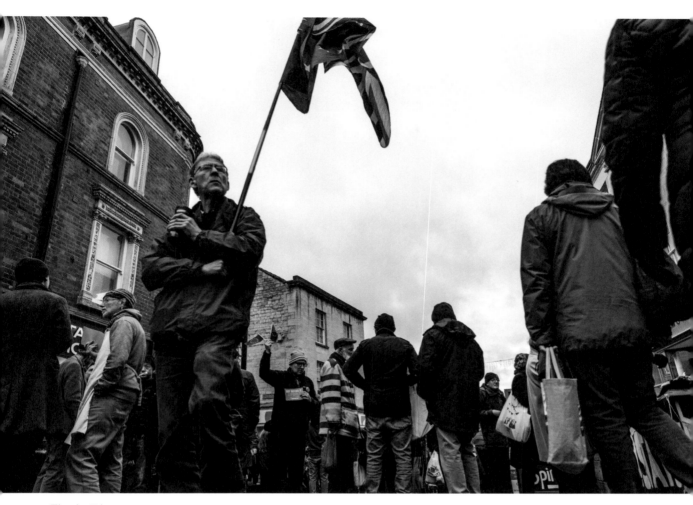

The battle rages on.

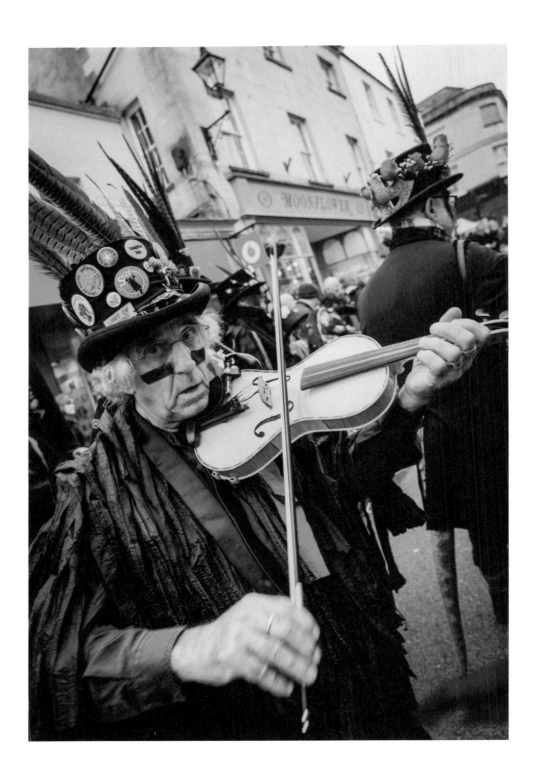

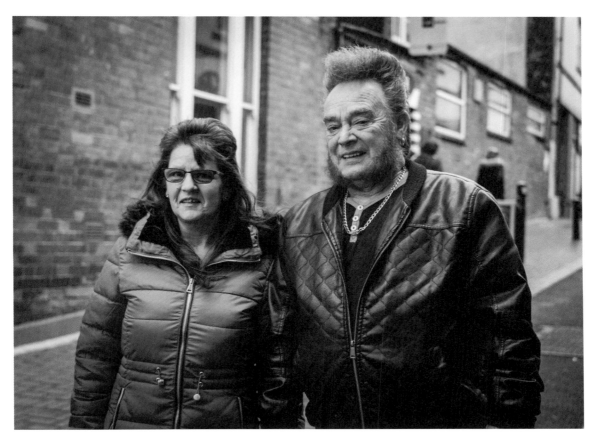

Mr & Mrs Teddy Wolverine (Pete & Dawn).

Opposite page: poised to play you a tune.

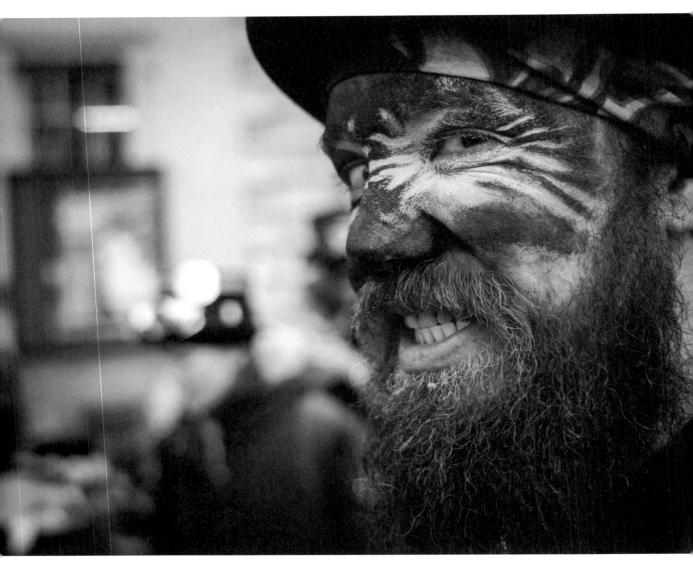

Tatters and Tails.

Opposite page: 'Here we come a-wassailing, among the leaves so green.
Here we come a-wand'ring, so fair to be seen.' (Traditional carol)

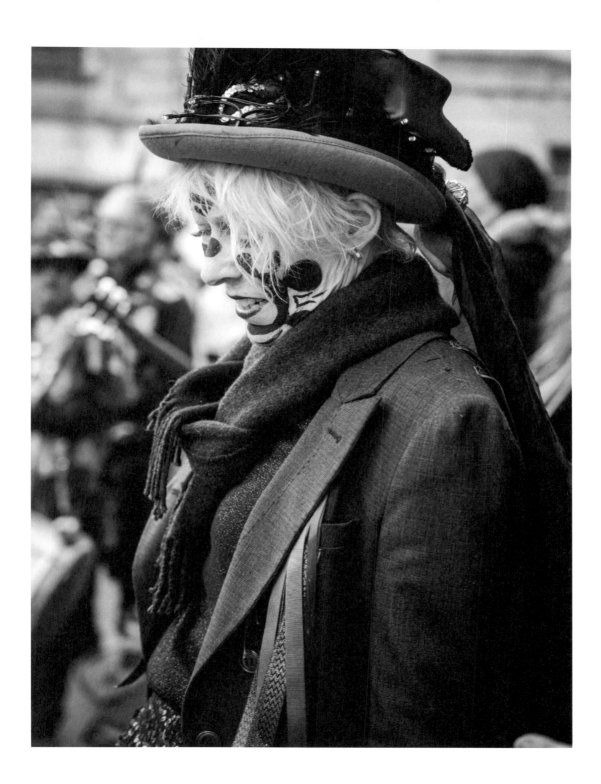

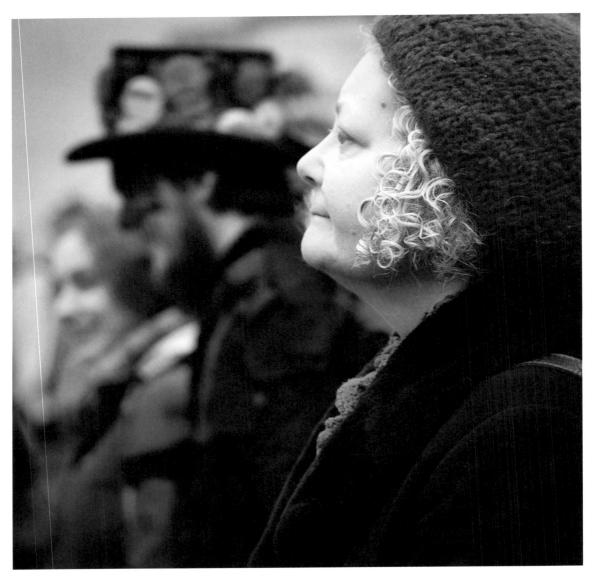

A wassail to raise the spirits in the depths of winter. To good health!

Opposite: tattoo parlour.

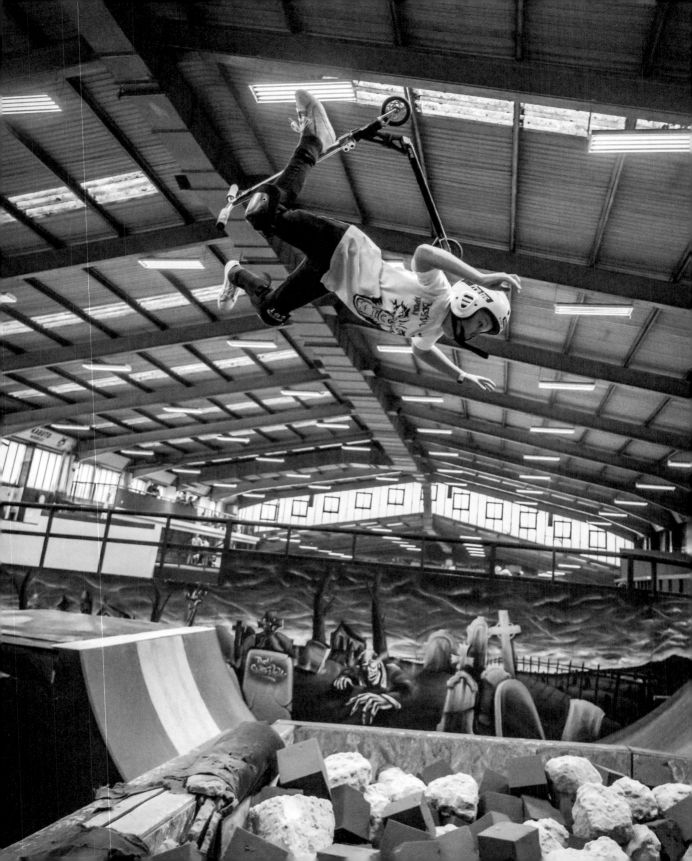

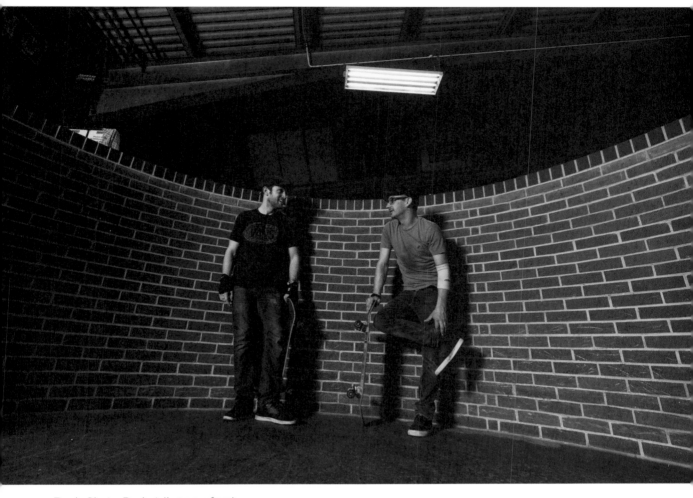

Rush Skate Park, 'silver surfers'.

Opposite page: Rush Skate Park. Wipe out!

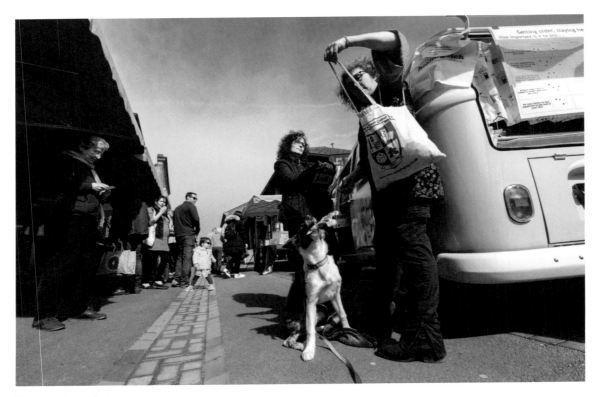

Farmers' market.

Opposite page: Hannah & Sean. Always looking fine!

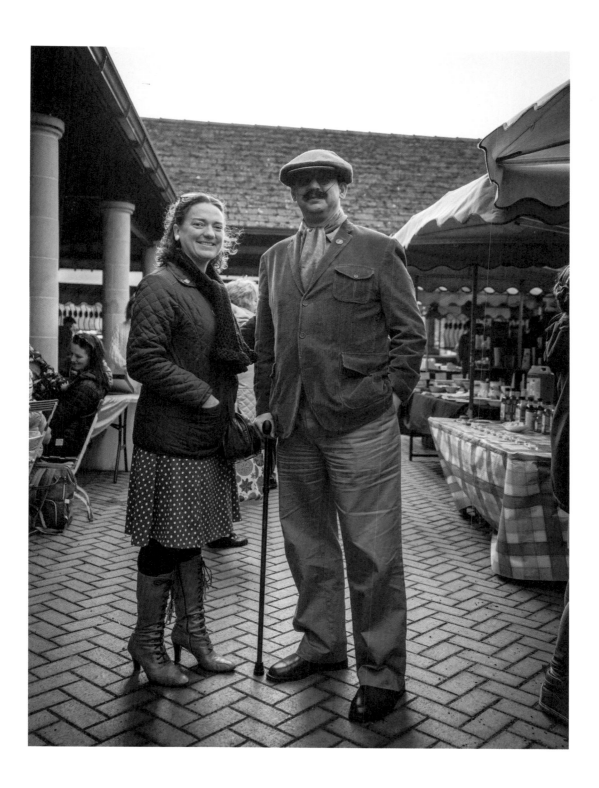

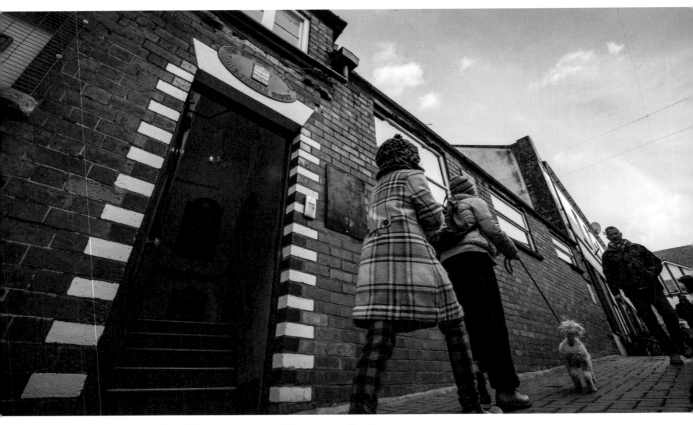

I've got a thing for this doorway on Threadneedle Street,
and have sat by it on quite a few occasions.

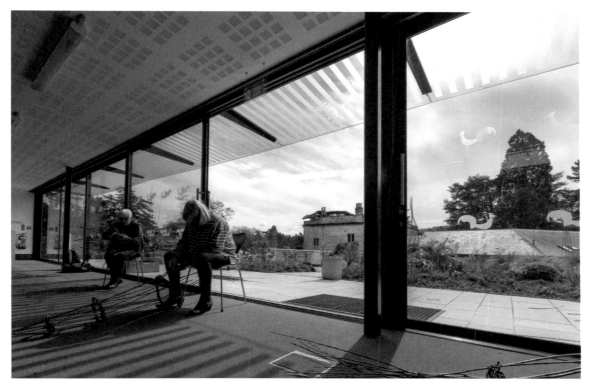

Making wicker at the Museum in the Park.

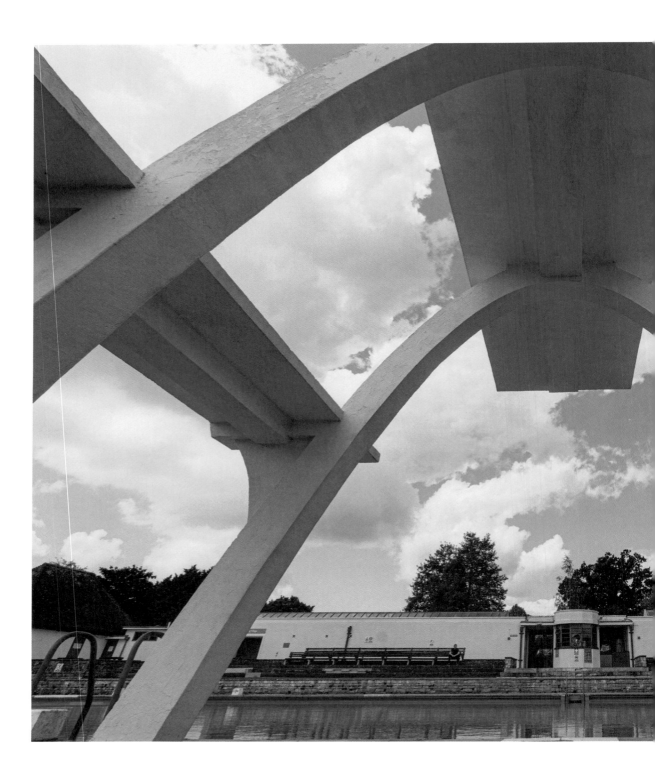

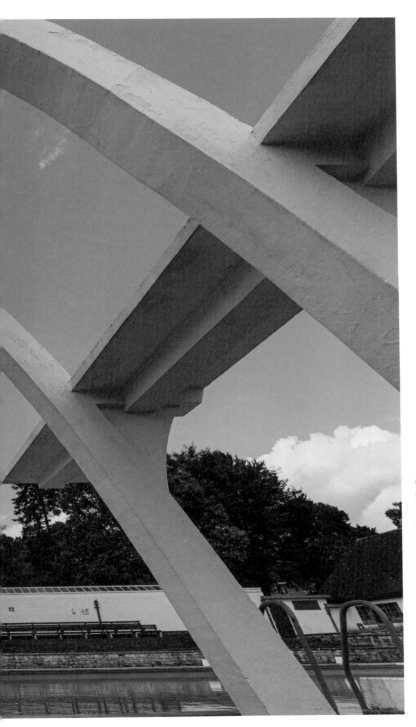

Outdoor pools in the UK are hopeful places and part of the romance that honours the 'British' spirit. It's almost a duty – no, a responsibility – for mums and dads to convince their kids to plunge into the numbing water on a summer's day. They've shut the diving platform now, for health and safety reasons as the pool is too shallow. But it remains standing, protected, its deco-curves preserved to be looked upon by a shivering generation as they're warmed by dad's hands in meadowed towels, munching on choc ices and crisps.

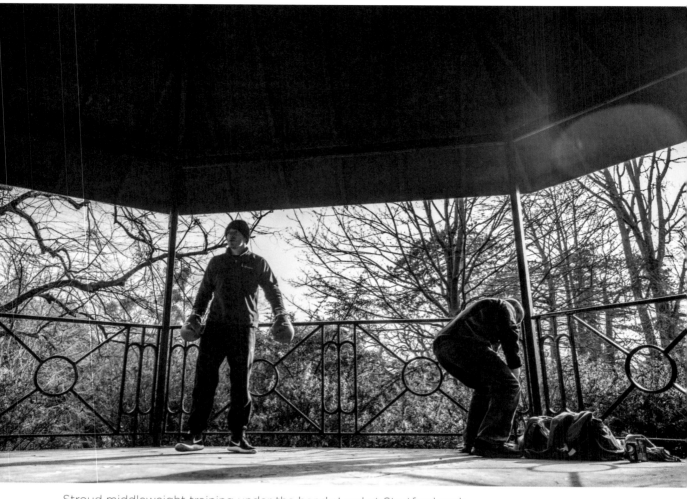

Stroud middleweight training under the band stand at Stratford park.

Opposite page: circus lights and anticipation.

What's behind the door?

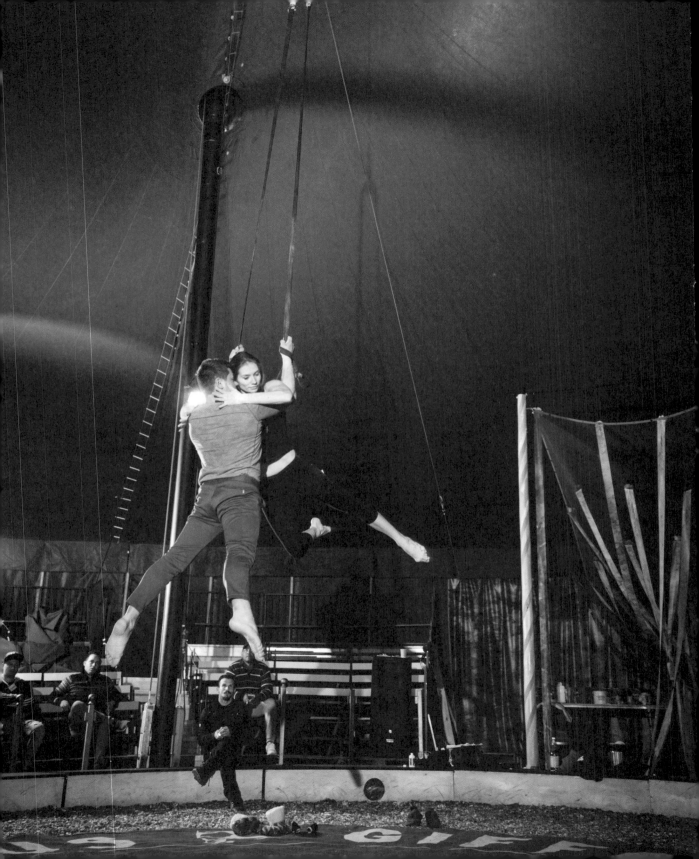

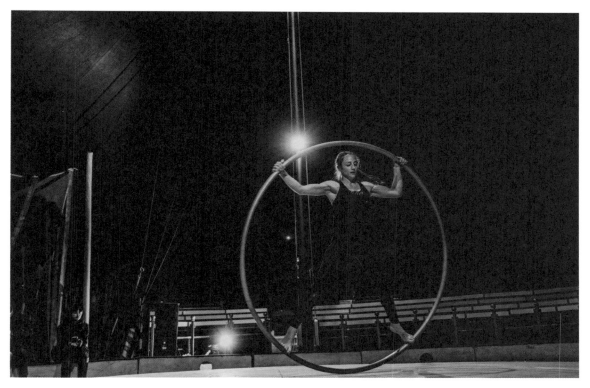

A circle of strength.

Opposite page: Giffords Circus perform.